Surveying Your
Arts Audience

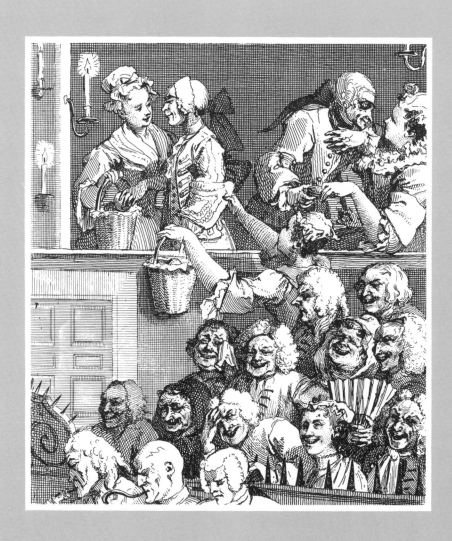

Surveying Your Arts Audience

 A RESEARCH DIVISION MANUAL

National Endowment for the Arts
Washington, D.C.
1985

Cover collage: "The Empire Theatre
1893–1943." Theatre Collection, Museum of
the City of New York.

William Hogarth: *The Laughing Audience.*
Etching, 1733.

Library of Congress Cataloging-in-Publication Data

Main entry under title:

Surveying your arts audience.

 1. Arts—Audiences—United States. 2. Arts
surveys—United States—Handbooks, manuals,
etc. I. National Endowment for the Arts.
NX220.S87 1985 700'.68'8 85-15466
ISBN 0-89062-203-5 (pbk.)

Designed by Christopher Holme
Produced by Publishing Center for Cultural Resources
Manufactured in the United States of America

□□

Contents

□□□

List of Illustrations

□□

Preface

□□

**Why and how
this manual
was developed**

Research studies on the audience for the performing arts and museums have increased markedly in recent years. Arts managers need to know who makes up their audience and how that audience can be better reached and served. The research method of choice for understanding the arts audience has, increasingly, become the audience survey.

In 1978, the Research Division of the National Endowment for the Arts published a report that analyzed 270 such audience studies *(Audience Studies of the Performing Arts and Museums: A Critical Review,* Research Division Report #9). Among other things, the report examined the quality of previous arts audience studies and their usefulness to arts organizations, concluding that "good audience research is scarce." It went on to note that regardless of the quality of results obtained, most survey findings did not exert a major influence in the formulation of arts policy because most audience research was not undertaken to solve specific problems.

In an attempt to remedy this situation, the National Endowment for the Arts Research Division proposed the creation and testing of an instruction book with which arts organizations could learn to conduct their own audience studies—and to make those studies more helpful for policy development.

The firm of Peter B. Meyer, Economic Planning, was competitively selected as the contractor and instructed by the Endowment to develop a manual with the following objectives:

> To inform arts organization personnel on what it takes to conduct a valid survey;
>
> To discourage poor surveys and thus raise the standards of audience information;
>
> To provide guidance on when survey consultants should be chosen as well as a reasonable idea of what to expect from a consultant in terms of audience survey specifications.

The manual was also supposed to follow certain guidelines. The content was to be useful in a wide range of arts settings and include a generic set of survey questions as well as step-by-step instructions on planning, conducting, analyzing,

and presenting audience surveys. The manual was to communicate the necessary information in ordinary language with a minimum of technical jargon. A draft of the survey manual was written by Dr. R. Richard Ritti and Dr. Peter B. Meyer with the assistance of Theresa J. Novak. The draft included generic survey questions.

Field tests of the draft were conducted to find out what the manual could actually do. Selection of test sites was guided by consideration that those tested reflected the variety of arts organizations that might use the manual and the breadth of their decision-making needs, and that they be geographically dispersed. Five organizations were chosen: the Mississippi Museum of Art (Jackson); the Newark Museum (New Jersey); the Seattle Opera Association (Washington); the Bangor Symphony Orchestra (Maine); the Karamu House (Cleveland, Ohio).

Site visits were made to monitor the progress of the five projects. Each organization was encouraged to do as much as possible by itself, using the manual for guidance. On the first visit to each organization, the draft of the manual was delivered and its use was explained to key personnel. The second site visits were made when the surveys were under way. The third and final site visits were made to review problems and to obtain a detailed critique of manual content and style.

A revised version of the manual was subsequently prepared and additional substantive and editorial work was provided by Dr. Mark R. Levy, associate professor of journalism at the University of Maryland, College Park.

Lessons from audience studies

The critical review of 270 audience studies published as Research Division Report #9 found much variation in the uses to which these studies were put by the institutions that commissioned them. No simple explanation was found for this, and interviews were conducted with the directors of organizations that had sponsored the studies as well as those who had conducted them to explore the puzzle. The general finding from these interviews was that, since these studies were rarely undertaken to solve specific problems, the information obtained from them could be applied in a variety of ways or not at all. Report #9 states: "The chief motives that were found for undertaking audience research were for political leverage, or because the opportunity was offered gratis, or out of a vague sense of concern for more information of some sort."

Nevertheless, applications were found for these audience studies. Use for physical planning was cited by 29 percent, marketing was cited by 20 percent, further research by 12 percent, and programming by 6 percent. Political application was cited by 34 percent. It was also apparent that these studies contributed to policy in indirect ways and in innumerable suggestive, expressive, and symbolic gestures that depended little on the precise technical methods employed.

The lack of technical quality that was found in most of the 270 audience studies can be regarded as understandable given the environment in which the

information was collected. However, the environment is changing. This is partly because of budget pressures and partly because of the gradual shift in attitude toward better information and improved planning in the arts. It is likely that greater use will be made of future audience studies if they have sound technical bases. Better-quality studies will inevitably be more authoritative and their results more convincing to policymakers than the shakily based studies of the past.

Acknowledgments

9

Many people contributed to this project and the development of this handbook. The members of a national advisory board who provided guidance, constructive criticism, and assistance in the selection of field research sites were Carolyn Adams of the Paul Taylor Dance Company and the Harlem Dance Foundation, both in New York City; Malcolm Arth of the American Museum of Natural History, New York City; C. Bernard Jackson of the Los Angeles Inner City Cultural Center; Trish Pugh of the Actors' Theatre of Louisville, Kentucky; David Wax of the Sacramento Symphony Orchestra Association, California; and Townsend Wolfe of the Arkansas Arts Center, Little Rock.

A reactor panel of arts organization directors in central Pennsylvania provided valuable comments on first drafts of this manual. We gratefully acknowledge the assistance of LaRue Allen, Central Pennsylvania Dance Workshop; William Davis, Pennsylvania State University Art Museum; Richard Gidez, State College Community Theatre; Marilyn Keat, formerly of the Central Pennsylvania Festival of the Arts; Jacquelyn Melander, Junior Museum; D. Douglas Miller, State College Choral Society; and Helen Neuhard, Art Alliance of Central Pennsylvania.

We also wish to thank the staffs and volunteers of the organizations that tested the manual on their audiences.

Research Division
National Endowment for the Arts
July 1985

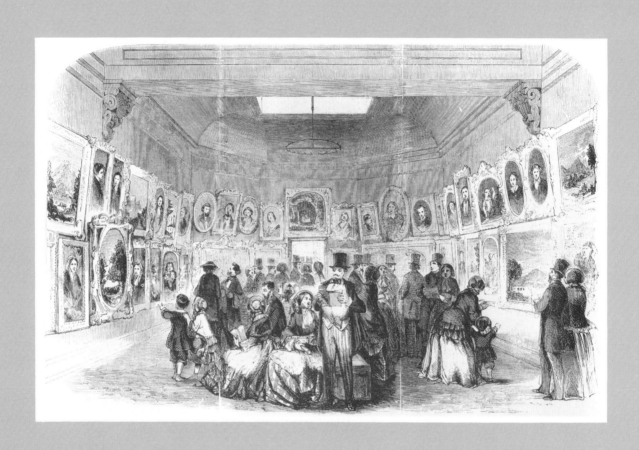

I.
Why an Audience Survey

11

Arts management involves making many decisions, and the effective use of research is one of the most valuable aids. There are many kinds of research, of course, but in cases that involve audience attitudes and behavior, the best way to get facts that are reliable and actionable is usually through a survey. Facts, in and of themselves, don't solve problems and don't make decisions obvious or easy. But the information that a well-designed and well-conducted survey can produce will improve the likelihood that your decision and the resulting action will be successful.

This manual gives you the tools for valid audience research. But having the tools and understanding how to use them is only half the battle. The purpose of conducting an audience survey is to put its findings to use. Those findings become usable only when key decision makers interpret them in usable ways. The problem, of course, is getting people to agree on what the facts mean and what ought then to be done.

While there is no magic formula for the effective use of audience surveys, there are a few guidelines that make success more likely:

Know precisely why you are making the survey.
Get agreement on the problem from the important people in your organization.
Agree beforehand on the potential significance of certain results.
Follow the rules of survey research carefully and precisely.

A significant part of the effort that goes into mounting a good audience study is made well before any sample is drawn, before any specific questionnaire items are written, and before anyone is interviewed. It is not enough to have a vague notion that you would like to "know more about our audience" or believe that "we could attract bigger crowds if we changed some of our offerings." Since the purpose of your audience survey is to get answers to important questions, a crucial first step must be to state those questions very explicitly and very clearly. Equally important is advance consideration of how results will be interpreted and what action your organization is prepared to take based on those interpretations. Setting the ground rules for interpretaton and getting advance agreement on standards of evaluation will make it substantially easier to turn the findings of your study into policy.

What can be learned from the different types of audience studies?

Audience identification. One kind of survey typically details the demographic characteristics of an audience, yielding breakdowns by sex, age, income, occupation, education, and the like. It also tells you where people in your audience live, how far they have to travel, and what means of transportation they use. Such

Galleries of the National Academy of Design. Engraving, 1853. "The beauty and fashion that throng the rooms make it a place of agreeable resort, independently of the paintings." New Mirror

information can help arts organizations target advertising and public relations efforts and develop funding and other support.

Facilities development. Other surveys focus on the physical conditions surrounding performance. How does your audience feel about such matters as parking arrangements, seating plans, or ease of access? Are your events or performances scheduled at convenient times? Is the setting for your events pleasing? Are there enough rest rooms? Snack bars?

Audience development. To reach more people or attract audiences you are not now reaching, you may want to compare current audience data with the characteristics of the larger community. Are there, for example, segments of the community that have not heard about your arts offerings or are aware but not interested? Comparing arts attenders with nonattenders may require a community survey—a large and complex undertaking—or you may be able to find already existing community characteristics data. (Chapter IV discusses community surveys and other sources of community data.)

Program development. The primary purpose of some surveys is to help structure artistic offerings. Of course, the selection of arts offerings is a highly complex (and often political) matter involving judgments by artistic directors and other professionals. Still, careful planning by artistic and professional decision makers can use the results of surveys of audience preference to refine and structure presentations. (Keep in mind that a survey of preferences expressed by your current audience need not indicate what nonattenders might like.)

Trend analysis. By asking exactly the same questions in a number of audience surveys over a period of time, it is possible to track continuity and change in your arts audience. From an analysis of trend data, it is possible, for example, to answer such questions as: Is your audience changing? Have changes in arts policy allowed you to reach previously untapped publics? Compared to six months, a year, or five years ago, are people more or less satisfied with offerings and facilities?

The pages that follow take you step by step through the process of conducting an audience survey. Follow these instructions and your research will be of high quality. But remember, there is only one reason for an audience survey: to get information that will help you bring about some important improvement or change. Putting audience surveys to work takes planning, dedication, and a willingness to follow through.

II.
Developing the Questionnaire

13

Ask the right survey questions and you will get answers you can use. Ask the wrong questions, or ask them poorly, and you will be wasting your time—or worse, you will be getting misleading information. This chapter introduces you to the different types of survey questions and explains their use. It also offers some practical dos and don'ts in questionnaire construction. By the end of this chapter, you will be able to begin writing your own survey questions. However, there is no reason to "reinvent the wheel," and an appendix to this manual contains more than fifty questions that can serve as a starting point for your own audience survey. The questions are written in generic form, allowing you to insert the specifics of your arts activity. Five subject areas are covered by the questions:

> Demographic information (attender age, income, education, etc.)
> Attender satisfaction (levels of event enjoyment, comparative evaluations of performers, etc.)
> Attendance factors (why attended, ease of attendance, etc.)
> Marketing and pricing (source of tickets, feelings about cost of admission, etc.)
> Facilities (adequacy of facilities, ambiance, etc.)

The form of survey questions

There are two basic ways to ask questions in a survey: *open-ended*, in which the person being interviewed provides the answer using his or her own words; and *fixed-response, forced choice,* or *closed-ended,* in which the respondent is asked to choose the most appropriate answer from a number of provided choices.

The open-ended form of question is generally best when you are not certain what the range of answers might be or when you are particularly interested in the actual way arts attenders think about an issue. Moreover, open-ended questions give respondents the chance to vent strong opinions.

⊠ Open-ended questions

All in all, what did you like best about tonight's performance? (Please write your answer below.)

And what did you like least? (Please write your answer below.)

About how many blocks away from the museum did you park your car?

_____ blocks (Please fill in.)

What is the zip code of your home address?

_____ (Write zip code here.)

Open-ended questions have some disadvantages. One of them is that you must read all the responses and code them. *Coding* means first devising a set of categories that covers the range of all open-ended responses and then determining which answers fit which categories. Unfortunately, some answers will be ambiguous or otherwise impossible to code precisely. Another disadvantage is that, even under the best circumstances, coding open-ended responses is enormously time-consuming and requires a fairly knowledgeable and sophisticated staff.

For these and other reasons, most surveys use comparatively few open-ended questions. Fixed-response questions may be easier for the respondent to answer quickly, and thus he or she may be more willing to complete the questionnaire. Also, fixed-response items are easier to handle from the point of view of data processing—in many situations the answers can be precoded and entered directly into the computer.

Fixed-response questions are best used to ask about facts.

☒ Fixed-response questions

Are you: (Circle one.)

1—Female 2—Male

Is your age: (Circle one.)

 1—under 18 3—22 to 29 5—40 to 49 7—60 to 65
 2—18 to 21 4—30 to 39 6—50 to 59 8—Over 65

Was your total family income last year: (Circle one.)

 1—Under $10,000 3—$15,000 to 19,999 5—$30,000 to 50,000
 2—$10,000 to 14,999 4—$20,000 to 29,999 6—Over $50,000

Are you: (Circle one.)

 1—American Indian/Alaskan Native 4—Hispanic
 2—Asian/Pacific Islander 5—White, not Hispanic
 3—Black, not Hispanic

Fixed-response questions can inquire about behavior.

☒ Fixed-response questions about behavior

Did you attend a lecture while at the museum? (Circle one.)

 1—Yes 2—No

How much time did you spend today at this art gallery? (Circle one.)

 1—Less than one hour 3—Two to four hours
 2—One or two hours 4—More than four hours

Did you purchase your own ticket? (Circle one.)

 1—Yes, from the box office 3—No, it was given to me
 2—Yes, from someone else

Are you at the museum as part of an organized group (for example, a guided tour or church group)? (Circle one.)

 1—Yes 2—No

Finally, fixed-response questions can tap audience attitude or opinion.

How would you rate the following in today's performance? (Circle one.)

	Very good	Good	Fair	Poor	Don't know
a. Lighting	1	2	3	4	5
b. Sound	1	2	3	4	5
c. Costumes	1	2	3	4	5

How well was the theme of this exhibit represented by its content? (Circle one.)
 1—Very well 3—So-so 5—Not well at all
 2—Well 4—Not too well

How interested are you in the following kinds of exhibits or activities? (Circle one.)

	Very	Quite	Somewhat	Slightly	Not at all
a. Folk and craft fairs	1	2	3	4	5
b. Studio art classes	1	2	3	4	5
c. Historical exhibits	1	2	3	4	5

Compared to what you expected, how would you rate tonight's performance? (Circle one.)
 1—Much better than expected 4—Not as good as I expected
 2—Better than expected 5—Much worse than I expected
 3—About what I expected

Keep in mind that fixed-response questions must provide the full range of possible answers, and that those possible choices must be balanced. A full range of answers covers all logical possibilities. But if you cannot specify all possibilities, you have to leave your respondent some way to indicate an alternative.

Which of the following best describes the chief reason you attended this performance? (Circle one.)
 1—My own entertainment 5—Educational reasons
 2—To be with friends 6—Other (Please explain.) _____
 3—To be with husband, wife, special friend
 4—To take children _____

What type of admission ticket do you have? (Circle one.)
 0—Don't know 5—Senior citizen discount
 1—Single performance 6—Student
 2—Season subscription 7—Other (Please explain.) _____
 3—Free pass
 4—Group or party _____

Balancing fixed-response questions means giving equal numbers of possible answers that are for and against or positive and negative.

Do you feel that the cost of a subscription is: (Circle one.)

1—Too little 4—Somewhat too much
2—Somewhat too little 5—Too much
3—About right

How well do the following describe tonight's performance? (Circle one.)

	Very well	Well	So-so	Not too well	Not at all well
a. Entertaining	1	2	3	4	5
b. Shocking	1	2	3	4	5
c. Stimulated thought	1	2	3	4	5

16

A guide to spotting problem questions

Well-designed survey questions are *valid* (they measure what they are supposed to) and *reliable* (they yield consistent answers when repeated). As you try to write valid, reliable questions, here are some things to keep in mind.

Be specific. Do not assume that everyone will interpret a vague word or term the same way. For example, the question "Have you been to the museum lately?" mistakenly assumes that all respondents will supply the same meaning for *lately*. If they do not, then their answers will have little validity. Another example of a "don't" question is "Do you ever go to . . .?" Here the problem is the ambiguity of the word *ever*. It can be interpreted to mean at any time in the respondent's life or as an indication of current thinking on what might be an okay thing to do.

Use everyday language. Arts audiences vary enormously in their sophistication. Well-educated and cosmopolitan respondents will appreciate clear, direct language; for others, it is a necessity.

Never overestimate respondent knowledge. Most arts attenders are not experts. A question like "Do you think the museum's exhibit of primitive Celtic pottery compares favorably or unfavorably to those in other museums?" assumes knowledge that is beyond most respondents. They may guess at an answer, but it will be worthless unless you are after attitude and not fact.

Do not lead your respondents. Leading questions often come about because you are trying to supply a context for the question. For example: "Most people are willing to pay a higher price for admission if they. . . . How do you feel about this?" In the *most people* context it is difficult for your respondent to do other than agree.

Avoid offering a single socially desirable answer when providing fixed-response alternatives. In answering a survey, the respondent is also making some statement about himself or herself. For example, a question like "Which do you generally prefer, works that stimulate you intellectually or works that are pleasant but simple?" is biased toward a socially desirable self-image.

Keep your questions short and concrete. Just one horrific example: "Suppose that you had the choice between viewing the exhibit on aboriginal tribes of the Northwest or the exhibit on Celtic artifacts of North America, but not both. Furthermore, suppose that your party had several young children in it. From which of these exhibits do you think your entire party would derive the most benefit and from which the most enjoyment?" Faced with such a question, you should rewrite it, breaking it down into a series of simple, explicit items.

Stay away from "double-barreled" questions. For example, "How would you feel about a policy that provided for a special admission price for senior citizens and made up the loss in revenue through slightly higher prices for other admissions?" What's wrong, of course, is that it is impossible to know for sure if the respondent supports or opposes one or both policies. The remedy: rephrase as a series of two or more separate items.

Accentuate the positive. Writing survey questions containing the word *not* is often not a good idea. Why? Because respondents have a tendency to read over the word, thereby missing the entire point of the question. If you want to know whether respondents agree or disagree with a particular statement, give them the chance to pick an agreeing or disagreeing answer from a list of fixed responses.

Some special problems

As you are now aware, writing good survey questions can be tricky. If you are a beginner or if you plan to get into new topics or special purpose questions, it is advisable to get professional help. However, the generic questions provided in the appendix of this manual may be adequate with some minor modifications.

Changing response categories. In some situations you will know in advance that the standard response categories in the generic survey questions will not work for your audience. Say, for instance, that you have good reason to believe that nearly everyone in your audience is over age fifty; in such a case you might want to modify the responses for the standard age question to read:

Your age is about: (Circle one.)

1—Under 50	3—60 to 64	5—70 to 74	7—80 and over
2—50 to 59	4—65 to 69	6—75 to 79	

Similarly, in certain expansion arts situations, it is important to understand the income structure of a low-income audience. You might, therefore, rework the standard response categories to read:

Was your total family income last year: (Circle one.)

1—Under $2,000	4—$6,000 to $7,999	7—$15,000 to $19,999
2—$2,000 to $3,999	5—$8,000 to $9,999	8—$20,000 or over
3—$4,000 to $5,999	6—$10,000 to $14,999	

In this way you have "fine-tuned" the lower end of the income ladder while still providing a complete range of possible income responses.

18

Sometimes it is important to know the occupations or labor force status of arts attenders. There are many ways to ask about occupation. One that is adequate for many surveys uses a fixed-response question:

Which one of these best describes your *present main* occupation or activity? (Circle one.)

1—Sales or clerical	7—Homemaker
2—Manager or administrator	8—Student
3—Skilled worker/machine operator	9—Retired
4—Professional/technical worker	10—Other (Please explain.) _____
5—Laborer/farmworker	_____
6—Service worker	

Note that this list of fixed-responses does not approximate the U.S. Bureau of the Census categories. A way of classifying work status and occupation that is more comparable to the Bureau of the Census is given in the model survey questions of the appendix.

However, many studies have found that some people overestimate the importance of their jobs and will incorrectly classify themselves as managers, administrators, or professionals. If attender occupation is an especially important variable in your study, ask the following set of open-ended questions and take the time to analyze and classify the answers:

What is the name of your job or occupation?
What kind of work do you do in this job?
Where do you work at this job?

This combination of questions is not foolproof, but it will go a long way toward establishing just what the respondent does for a living. Based on the combination of answers, the individual respondent can be assigned a code, according to any number of different systems. See, for example, *1980 Census of Population, Classified Index of Industries and Occupations* (Washington, D.C.: U.S. Government Printing Office, 1982) or Otis Dudley Duncan, ''A Socioeconomic Index for All Occupations,'' in A. J. Reiss, Jr., *Occupation and Social Status* (New York: Free Press, 1981). Finally, if attender occupation is the make-or-break variable for your study, you would do well to consult an economist or sociologist who has special expertise in this area.

Resolving language difficulties. Certain groups in your audience may not use English as their first language. Translating the questionnaire may help, but in such situations our recommendation would be to work with the local community to devise an approach that is satisfactory to all. Indeed, we would recommend the same approach when dealing with other special groups: those who use nonstandard English, handicapped citizens, or senior citizens. With these special constituencies, care must be taken to make sure your questionnaire uses appropriate, culturally acceptable, and generally understood words and phrases. To do otherwise runs the risk of offending the very people you are trying to understand and serve.

Special art forms. From time to time, situations may arise that call for a special type of wording that cannot be adapted from the generic questionnaire. Take, for example, events that require audience interaction with objects or events. In the case of a kinesthetic sculpture exhibit, one might ask:

Do the following statements apply or not apply to the kinesthetic sculpture exhibit you've just seen? (Circle one.)

	Applies	Does not apply
a. Art objects are in working order	1	2
b. Directions for use are clear	1	2
c. "Please touch" signs are needed	1	2

While special art forms may require special response categories, there is nothing special about the form of the questions themselves. Here, too, all the rules of question writing apply.

Sequence of survey questions

Once you have written your survey questions, the next step is to put them into some sequence or order. Generally, there are four parts to a questionnaire: an introduction, warm-up questions, the body of the questionnaire, and demographic questions.

Even the briefest questionnaire requires some sort of prefatory or introductory material. Introductory materials should:

Identify for whom the survey is being done
Offer a very brief, general statement on why the survey is being conducted
Indicate what the respondent is supposed to do (e.g., "Please fill out this
 questionnaire and leave it with an usher.")

In writing a survey introduction remember to keep it short, keep it serious, and keep it nonthreatening. A good introduction should win the potential respondent's confidence and cooperation.

Next come the warm-up questions. These should be innocuous, easy to answer, rapport-building items. Properly designed warm-up questions will make your respondent want to continue. However, since you never have enough time or space to ask everything you might like to know, even warm-up questions have to be relevant to your overall research goals.

Following the warm-up questions, the questionnaire moves on to the main body. Questions here are often best grouped by logically related subjects. When the subject matter shifts, it is generally a good idea to use a brief transition phrase (e.g., "On another topic . . ."). Also, be aware that questions appearing early in a questionnaire may influence later answers. Early questions may lead respondents to overemphasize the importance of a later topic or to mention something that otherwise would not have occurred to them. In short, when ordering questionnaire items, take care not to tip your hand about upcoming questions.

The final section of many questionnaires asks for personal information about the respondent. Most people will be willing to give you answers if the questions are put in a way that does not seem intrusive or offensive. Indeed, demographic questions can be used as warm-up items. Saving the demographics for last, however, increases the chances that even reluctant respondents will have answered all questions excepting those that ask for personal information.

Pretesting questionnaires

Trying out survey questions before the study "goes into the field" is essential. What seems like a perfectly straightforward item to you and your colleagues may confuse or outrage a real-life respondent. To pretest a survey, select a small number of people (ten to twenty-five will often suffice) who are typical of the people you plan to interview. Try to select pretest respondents who have a variety of backgrounds, opinions, and experiences. Read them the questions or have them fill out a draft version of the questionnaire in your presence. After they have finished, go over the questionnaire with them item by item. Try to find out if any of the questions were unclear, annoying, or boring and whether the respondents thought the questionnaire took too long to answer. Try, if you can, to learn if the answers mean the same to you as to the respondents. By evaluating just a handful of pretest interviews, you will often catch potential problems in time to make changes in your survey.

Arts audience surveys: an illustration

Now that you have been introduced to the theory of writing survey questions, let's take a look at an actual survey done during the development of this handbook. The survey was conducted by the Mississippi Museum of Art in Jackson. In this survey, the museum staff had four major questions in mind: how did people learn about their museum; why did people visit their museum; how could the museum increase its paid memberships; and would it be feasible to charge admission fees for special traveling exhibits.

To help answer those questions, the museum staff designed a twenty-item questionnaire made up of eighteen fixed-response and two open-ended questions. Since the issue of paid memberships was considered the most important, it received the largest share of the survey questions. Question 11, for example, was a *filter* that divided respondents into members and nonmembers of the museum. Members were instructed to answer questions 12 and 13 about membership renewal. Because these questions were irrelevant for nonmembers, they were directed to question 14 (reasons for nonmembership). The museum staff hoped that a careful analysis of the responses to open-ended questions 13 and 14 would provide crucial information on the strengths and weaknesses of the museum's membership program. In addition, questions 15 to 17 (knowledge about membership benefits and respondent evaluations of those benefits) were expected to offer insights about possibly changing or increasing membership development efforts.

Other questions also dealt with the membership problem. For example, question 5 (respondent place of residence) was expected to show where museum visitors lived, which could shed light on a suggestion that memberships be offered at reduced rates to people who lived farther away. Museum staff also planned to compare the family incomes (question 3) of members and nonmembers. If museum members tended, for example, to be people with incomes of $30,000 or more and if very few respondents with lower incomes expressed any interest in joining the museum, then staffers were prepared to argue that raising membership fees by, say, five dollars would not cost the museum many members. By contrast, if the survey found that memberships appealed to people with a wide range of incomes, the museum staff felt the case could be made for a lower membership fee.

The issue of charging admission fees for special exhibits was raised directly in question 20. This "what if" type of question is often essential in policy planning. But hypothetical questions call on the respondent to make an informed guess, and since it is only a guess the answers must be evaluated with some caution.

Questions 6 and 7 represent an attempt to gather information that would help plan outreach efforts. Combining the results from those two items with, for example, the demographic items (questions 1 to 4) was expected to show what kinds of advertising and promotion strategies might reach what parts of the public. (You will notice that question 4 differs slightly from the similar question in the first box on page 14. We feel that the additional clarification, "not Hispanic," in the box helps avoid a frequent matter of confusion since Hispanics may be black or white.) Finally, questions 18 and 19 (museum appeal to children) were included because the museum staff wanted to know to what extent opinions about the museum experience were a function of having youngsters along. They also serve as an indirect but valid measure of how much children enjoyed the museum.

1. Into which of the following age categories do you fall?
 1—Under 18 3—26 to 35 5—46 to 55 7—66 and older
 2—18 to 25 4—36 to 45 6—56 to 65

2. Which category below best describes the level of education you've completed?
 1—Elementary school 5—Technical school graduate
 2—Some high school 6—Community college graduate
 3—High school graduate 7—College graduate
 4—Some college 8—Post-graduate work/degree

3. About what was your total family income before taxes last year?
 1—Under $10,000 4—$20,000 to $29,000
 2—$10,000 to $14,000 5—$30,000 to $50,000
 3—$15,000 to $19,000 6—More than $50,000

4. Are you
 1—American Indian/Alaskan Native 4—Hispanic
 2—Asian/Pacific Islander 5—White
 3—Black

5. Where is your current home?
 1—In Jackson
 2—Outside Jackson, but within Hinds, Rankin, or Madison County
 3—Within Mississippi, but outside Hinds, Rankin, or Madison County
 4—In Louisiana, Arkansas, Alabama, or Tennessee
 5—In some other state, but within the United States
 6—Outside the United States

6. What made you decide to visit the Mississippi Museum of Art (MMA) today?
 Check as many as apply:
 1—Came to see an exhibit(s) 5—Was in the neighborhood/area
 2—Came to see a film 6—Other _____
 3—Came for a concert _____
 4—Came to eat at the Palette

7. How did you hear about the exhibit/film/concert/Palette?
 1—Newspaper 4—Word-of-mouth
 2—Radio/television 5—Other: _____
 3—MMA newsletter, *Perspective* _____

8. Overall, how did you enjoy your visit to the MMA?
 1—Extremely well 3—Only somewhat
 2—Quite well 4—Not at all

9. What did you enjoy the most?
 1—The permanent collection 5—The Palette
 2—The exhibit of _____ 6—A concert
 _____ 7—Other: _____
 3—A film _____
 4—Museum Sales Gallery

10. Would you recommend a visit to the MMA to a friend?

 1—Yes 2—No

11. Are you a member of the MMA?

 1—Yes 2—No (Please go to question 14.)

12. If you answered "yes" to question 11, do you plan to renew your membership?

 1—Yes (Please go to question 16.) 2—No

13. If you answered "no" to question 12, please tell us why.

14. If you are not a current member, please tell us why.

15. If you are not a current member, do you think a membership would be worthwhile?

 1—Yes 2—No 3—I don't know

16. Do you know the benefits of being a member of the MMA?

 1—Yes 2—No

17. If you answered "no" to question 16, here are some benefits of an MMA membership: discounts on film admission, discounts on museum school tuition, discounts at the Sales Gallery, invitations to exhibition preview receptions, and a subscription to the MMA newsletter, *Perspective*. Do you think this makes a membership worthwhile?

 1—Yes 2—No

18. Did you bring any children to the MMA today?

 1—Yes 2—No

19. In your opinion, does the MMA have programs/exhibits that children can enjoy?

 1—Yes 2—No

20. If there were an admission fee for future gallery events (demonstrations, lectures, tours, etc.) would you be likely to attend?

 1—Definitely would 3—Can't say 5—Definitely would not
 2—Probably would 4—Probably would not

Obviously, we have not discussed all the different kinds of information that can be gleaned from a careful analysis of this survey. Rather, we have attempted to show, first, how policy questions can be translated into survey items; and, second, how analysis of a well-designed survey can produce results with important policy implications.

III.

Sample design

25

Sample design is among the most technical aspects of survey research. It is also among the most important. Careful attention to the details of sample design is the hallmark of a good audience survey. How and why you choose your respondents can make the difference between an exercise in futility and an exercise in successful arts management.

In this chapter, we introduce some of the key terms and concepts of survey sampling and outline detailed procedures for gathering different types of samples. By following the instructions presented here, you will be able to design most common arts-oriented samples. But if you have a special situation, it may be wise to get help from an experienced survey researcher or sampling statistician.

Key terms and concepts

A *sample* is a small group of people chosen to represent a larger group. The larger group is called the *universe* or *population*. Because of the laws of probability, it is often unnecessary to gather information from the entire population. Answers from only a small number of people may be representative of what the entire group knows, thinks, believes, or does—if that sample has been correctly chosen.

There is only one correct way to choose a sample if you want to be sure that it is representative. That method is *probability sampling* and what it produces is a *random sample*. Random does not mean haphazard here. In survey terminology, random means that:

1. The researcher has no control over who gets picked for inclusion in the sample; instead, selection depends entirely on probability or chance; each person in the universe or population studied has the same chance of being picked.

2. Each person or other *population unit* (determined by presence at a particular site, on a particular day of the week, or at a particular type of performance) has a known chance (probability) of being selected. If there are 8,307 paid members of a museum and you want to draw a simple random sample of museum members, the odds that any one person will be randomly selected are exactly the same for each person of this group.

The larger the sample, the more representative it will be of the population from which it was drawn regardless of the size of the population. A random sample of, say, 1,000 people drawn from a list that contains 10,000 names will be just about as representative as a sample of 1,000 people chosen at random from a list of 100,000 names. In short, because of the laws of probability, the precision of sample data is related more to the size of the sample than to the proportion of the population sampled.

Because a sample is only part of a population, the answers you receive must be considered as only estimates of the "true" answer you would get if you surveyed

Visitors Taking Notes *at the U.S. Centennial Exposition, 1876. Engraving from* Frank Leslie's Historical Register.

the entire population. The difference between the answers you get from a sample and the answers you would have gotten by asking everyone in the population is called *sampling error*. Larger samples give you more precise estimates and have smaller sampling errors. Unfortunately, larger samples generally cost more—it takes more money to interview more people—so you should pick a sample size that meets but does not exceed your need for precision. Arts audience surveys are usually based on samples of 400 to 1,000 people.

⊠ Sample size
and sample precision
(plus/minus variance)

This table shows how sample size affects the precision or accuracy of survey results. You can use it to estimate how many people you will have to survey. The safest approach is to use the 50 percent column, since it tells you for a given sample size how accurate your results are likely to be for the "closest call"—that is, for any question where the "yes" and "no" answers divide about fifty-fifty.

Sample size	Survey Result										
	1% or 99%	5% or 95%	10% or 90%	15% or 85%	20% or 80%	25% or 75%	30% or 70%	35% or 65%	40% or 60%	45% or 55%	50%
25	4.0	8.7	12.0	14.3	16.0	17.3	18.3	19.1	19.6	19.8	20.0
50	2.8	6.2	8.5	10.1	11.4	12.3	13.0	13.5	13.9	14.1	14.2
75	2.3	5.0	6.9	8.2	9.2	10.0	10.5	11.0	11.3	11.4	11.5
100	2.0	4.4	6.0	7.1	8.0	8.7	9.2	9.5	9.8	9.9	10.0
150	1.6	3.6	4.9	5.9	6.6	7.1	7.5	7.8	8.0	8.1	8.2
200	1.4	3.1	4.3	5.1	5.7	6.1	6.5	6.8	7.0	7.0	7.1
250	1.2	2.7	3.8	4.5	5.0	5.5	5.8	6.0	6.2	6.2	6.3
300	1.1	2.5	3.5	4.1	4.6	5.0	5.3	5.5	5.7	5.8	5.8
400	.99	2.2	3.0	3.6	4.0	4.3	4.6	4.8	4.9	5.0	5.0
500	.89	2.0	2.7	3.2	3.6	3.9	4.1	4.3	4.4	4.5	4.5
600	.81	1.8	2.5	2.9	3.3	3.6	3.8	3.9	4.0	4.1	4.1
800	.69	1.5	2.1	2.5	2.8	3.0	3.2	3.3	3.4	3.5	3.5
1,000	.63	1.4	1.9	2.3	2.6	2.8	2.9	3.1	3.1	3.2	3.2
2,000	.44	.96	1.3	1.6	1.8	1.9	2.0	2.1	2.2	2.2	2.2
3,000	.36	.79	1.1	1.3	1.5	1.6	1.7	1.7	1.8	1.8	1.8
4,000	.31	.69	.95	1.1	1.3	1.4	1.4	1.5	1.5	1.6	1.6
5,000	.28	.62	.85	1.0	1.1	1.2	1.3	1.4	1.4	1.4	1.4
10,000	.20	.44	.60	.71	.80	.87	.92	.95	.98	.99	1.0
50,000	.08	.17	.24	.29	.32	.35	.37	.38	.39	.40	.40

In determining sample size, you must decide how much precision you need, whether, for example, you will be satisfied with results based on a sample size of 100 and with answers that are accurate plus or minus 10 percentage points.

Fortunately, answers to most survey questions rarely split 50 percent "for" and 50 percent "against," so for the majority of the time most results will be more precise than the worst-case figure given in the 50-percent column.

Here is how to read the table. First, read down the column of sample sizes until you reach one you can feel comfortable with—say 250. Then read across the 250 line until you reach the last column of the table headed 50 percent and the number, 6.3. This number means that, for a simple random sample of 250 people, a question to which 50 percent of your respondents answer "yes" and 50 percent answer "no" is accurate plus or minus 6.3 percent. In other words, if you interviewed the entire population and not just a sample, then you would have found the "true" answer. And that "true" answer might differ from the fifty-fifty response you got by 6.3 percent.

If you need greater precision in your answers, simply increase the sample size. Doubling the number of interviews to 500, for example, reduces the margin of error to plus or minus 4.5 percent.

In addition to sampling error, two other kinds of inaccuracies creep into surveys: *sampling biases* and *nonsampling biases*. Sampling biases arise because of technical mistakes or procedural difficulties during the actual choosing of the sample. As a result, the sample is not truly representative of the population. Careful attention to detail and a thorough understanding of the population being sampled will keep sampling biases to a minimum. Nonsampling biases come about because of such things as poor question construction, inadequately trained and supervised interviewers, or errors in data processing and analysis. One result is that some special groups in the sample may not answer certain questions. Here, too, attention to detail can keep these inaccuracies from *spoiling* your survey.

Finally, it is important to understand the concept of *filling the sample plan*. To fill the sample plan means simply choosing a sampling design and sticking to it. Getting interviews with a certain number of people is not as important as how you get those interviews. Of course, the more people you sample, the greater the precision of your data. But unless that sample is random and unbiased your findings will not be representative no matter how many people you interview.

Take this example: Suppose you want to survey all households in your community to find out how many people plan to attend the arts festival. You have a complete list of telephone numbers and you have taken a random sample of those numbers. You are using volunteers to make the phone calls, but they agree to work only from 10:00 a.m. to 3:00 p.m. Your instructions are for them to call the randomly selected phone numbers until they reach the potential respondent and to make no substitutes. However, some people are hard to reach by phone during these hours, so your volunteers take it upon themselves to call a slightly different number than the one given them. They get the job done faster and it looks as if you have completed the survey. But, of course, you haven't. By deviating from the sampling design, by failing to fill the sample plan, your well-meaning volunteers have introduced an unknown amount of contamination into the study. They have wrecked the probability basis for your sample, producing biased data of little value.

To be representative, a sample must be unbiased both in design and practice. One way to check up on bias in practice is to examine a survey's *response rate*. Response rate is roughly the number of questionnaires completed divided by the total number distributed. The higher the response rate, the greater the number of people who completed your survey. Since it is often difficult to know why some people respond to a survey and others refuse to participate, and how participants and nonparticipants differ with regard to questions being asked, a survey with a response rate of under 60 percent should be judged as probably not filling the sample plan; it is most likely biased and as such should be discarded. (Sometimes, an expert can devise a test of the nature and extent of the bias and this may salvage a survey.)

The number of questionnaires completed will almost always be smaller than the number called for in your sample design. The result is normal and presents no problem unless the response rate falls unusually low. To calculate response rate percent, divide the number of completed questionnaires by the number of questionnaires administered and multiply by 100.

Here are good rules of thumb about response rates:

If the response rate is 75 percent or higher, use the data collected with complete confidence.

If the response rate ranges from 60 percent to 75 percent, you can be reasonably confident in your findings.

If the response rate falls under 60 percent, use the data collected with considerable caution because you may have results based on a highly unrepresentative sample.

With a response rate of under 50 percent, throw out all the data collected and consider conducting another survey, but only after you have found out what went wrong. If you conduct a second survey, do not mix the data from the first, low-response survey with the new findings. To do so would retain some effect from the unrepresentative sample.

If you get an unacceptable response rate, look for the following:

Weakness	*Result*
Too many questions	Respondents were tired or bored
Too many open-ended questions	Respondents were tired or bored
Illogical or incomprehensible questions	Respondents were confused or annoyed
Poor questionnaire collection	Respondents did not return completed forms
Poor questionnaire printing, format, design	Respondents could not read questionnaire or follow the instructions
Poor introduction to questionnaire	Respondents did not see why they should bother answering

Of course, if you have a response rate of under 60 percent and you cannot find a flaw in your procedures or questionnaire, you will need expert help to determine what went wrong. A survey consultant, however expensive, may be less costly than another botched survey.

28

Types of samples

A representative sample can be drawn in a variety of ways. The method you use depends on a number of factors. The "decision tree" following will help you decide which sample design is most appropriate for a given study.

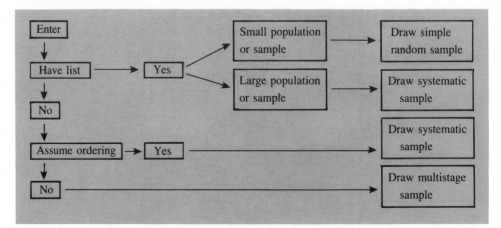

Enter the decision tree at the upper-left corner. The first question to ask yourself is: Do I have a *list* of the people in the population that I want to sample? If you have a list of, say, museum members, concert series subscribers, or people who have signed up to participate in a crafts festival, you may be able to use a simple random sample design. Before deciding on a simple random design, however, you should ask yourself one more question: How large a sample do I need? If you are planning a relatively large sample, say 1,000 respondents or more, you may prefer to use *systematic random sampling*. But if you are planning a comparatively small sample, or if you are willing to put up with a relatively easy but tedious sampling approach, then use simple random sampling.

A *simple random sample* is like a lottery, or like drawing pieces of numbered paper out of a hat. Every unit or element in the population has an equal chance of being included in the sample. Indeed, it is the easiest way of drawing a sample. To construct a simple random sample, you will need a complete listing of the population, a table of random numbers, and a fair amount of patience.

29

⊠ How to use a table of random numbers

Regardless of the type of survey you are planning, at some point you may need to draw a simple random sample and will have to use a table of random numbers like the one on the following pages to draw the sample. Here is how to do it:

1. Start anywhere on the table. It doesn't matter where; one place is with the first number in the first row in the upper-left corner. (If you use the table more than one time, always start in a different place.)

2. Flip a coin to determine whether you will read across the first row or down the first column.

3. Take the numbers in sequence, reading as many numbers as there are digits in the count of the population you are sampling. (Example: If you want to randomly select respondents from a list of 8,849 names, you must use any randomly selected number from 1 through 8,849. That means any four-digit number in the table from 0001 to 8849. Turn to the table provided here. Disregard how the numbers are grouped [three to a column]—that is just to make it look pretty. Read across the first row taking the first four numbers you encounter: 5, 9, 9, 6. That number falls between 0001 and 8849 and so is acceptable for your sample.)

4. If a random number in the table is larger than the population you are sampling, discard it and go on to the next number in sequence. (Example: The next four-digit number on our table is 9107. Since it is larger than the 8,849 names on the list we are sampling, discard this number and try the next one, which turns out to be 4879 and is acceptable.)

5. Continue reading through the random number table, accepting or rejecting numbers according to the rules given in Steps 3 and 4, until you have found as many numbers as you need. If, for example, you want a sample of 250, repeat Steps 3 and 4 until you have located 250 distinct numbers.

6. If the same number comes up more than once (which could happen), disregard it the second and subsequent times it occurs.

7. Do not start over just because the random numbers you have picked look wrong. Keep going. The laws of probability are on your side and odds are you will wind up with a usable set of numbers.

You may have a pocket calculator or a personal computer that can generate random numbers. These can be used in the same way as a table. Be sure to follow the instructions with the calculator or computer program carefully.

599	691	074	879	203	217	732	785	958	715	740	196	216	021
839	761	219	420	271	677	836	051	623	634	458	110	725	018
413	538	103	640	436	028	243	330	632	376	545	769	079	762
049	185	470	838	339	368	853	786	279	815	703	897	870	413
182	554	531	351	725	972	236	141	238	801	822	401	868	602
039	755	488	978	355	730	165	878	311	677	151	288	906	023
592	944	829	568	212	031	582	642	155	069	308	574	369	210
035	757	066	276	770	374	303	355	967	622	698	347	155	516
565	696	689	807	459	736	162	328	013	441	805	933	563	567
576	987	728	112	511	445	475	545	585	149	725	525	345	588
033	909	757	508	409	463	163	693	035	693	172	251	947	743
820	289	333	655	835	424	441	431	059	383	644	518	209	738
689	513	367	502	124	416	813	030	541	116	733	632	550	511
707	512	721	975	705	946	382	630	185	489	304	687	700	849
490	800	180	450	234	024	528	871	339	459	674	188	597	357
821	423	052	845	139	924	856	820	023	974	276	736	100	829
782	013	797	605	018	547	627	030	312	577	321	651	814	735
737	686	130	754	316	004	104	569	883	212	616	241	878	089
377	594	803	390	648	798	064	980	592	961	331	863	251	473
159	870	715	040	072	790	186	042	238	682	193	651	345	274
317	023	980	229	662	221	928	062	786	289	651	385	181	740
257	533	025	282	484	934	967	587	885	346	869	007	192	312
226	510	818	221	544	192	183	645	893	495	280	139	352	184
693	083	044	361	244	297	571	384	351	866	289	918	321	747
662	794	933	516	795	809	308	578	323	101	060	690	195	433
516	323	543	983	612	007	981	527	643	627	192	285	172	444
928	144	397	872	196	756	801	868	824	328	571	603	085	805
110	417	744	324	660	504	507	898	176	453	268	409	455	954
958	482	175	685	516	906	597	401	743	980	346	380	962	829
100	133	105	785	794	780	380	351	140	244	097	025	121	704
713	089	579	931	588	590	995	576	065	273	376	257	239	810
982	275	134	045	642	579	655	535	351	919	879	078	172	852
483	956	096	598	123	434	121	397	134	661	422	673	258	473
570	780	187	233	155	634	601	486	098	031	343	785	917	413
931	266	246	407	800	142	587	593	812	680	516	823	659	551
384	755	195	128	560	572	702	607	264	770	118	383	052	124
048	165	794	346	280	842	223	130	508	263	299	285	111	511
147	980	822	906	687	309	226	664	163	199	699	111	083	038
128	186	234	847	857	291	369	479	201	665	689	044	763	228
014	882	236	714	185	063	876	640	055	570	936	933	885	360
322	540	176	965	163	720	985	161	644	660	938	073	777	192
443	496	132	498	341	382	366	629	725	935	773	002	866	506
421	393	655	538	624	381	473	939	770	766	264	777	088	662
566	908	303	060	142	474	719	010	752	623	065	611	691	493
996	767	582	772	025	307	466	961	414	155	213	367	835	594
186	579	817	054	467	771	395	434	326	297	910	302	511	615
151	251	942	983	503	901	490	003	276	999	903	025	048	059
902	155	535	939	306	292	367	092	960	445	659	447	584	948
517	505	372	688	538	420	045	803	101	958	580	685	642	109
816	061	634	524	168	375	744	653	670	116	739	599	931	214

573	364	299	058	127	011	412	370	154	111	434	803	288	687
169	874	525	197	101	313	195	186	047	479	703	132	174	766
773	409	747	206	374	651	358	001	103	293	111	527	381	376
212	994	290	428	241	737	513	012	071	609	547	459	934	303
905	437	857	185	300	807	823	206	607	420	372	073	222	325
748	336	831	185	717	819	008	703	086	908	900	594	604	439
019	786	461	291	498	640	935	573	791	504	070	366	293	442
894	939	675	025	346	001	550	929	166	771	773	328	352	681
161	475	630	156	279	658	991	465	960	326	516	498	815	551
854	661	352	694	060	148	449	451	538	596	580	496	310	987
396	597	304	076	417	764	708	742	844	604	622	743	573	259
398	145	953	578	418	258	793	819	206	403	264	083	488	032
991	817	540	112	747	129	513	371	245	905	811	382	382	180
201	972	931	723	979	722	483	522	552	555	654	073	151	093
880	839	991	655	525	363	782	703	098	786	209	847	247	940
161	007	947	547	939	176	702	819	033	106	727	141	435	033
088	474	954	623	801	088	982	978	380	321	908	792	995	046
555	881	222	158	411	282	995	457	053	639	226	302	874	153
802	255	149	410	486	123	947	215	401	405	375	287	395	738
488	802	598	271	180	726	805	494	772	120	393	098	368	147
142	141	942	850	625	409	926	779	087	548	764	531	619	717
125	828	564	167	334	591	220	223	236	155	799	641	667	649
758	790	209	722	056	194	239	654	495	068	782	055	433	795
906	506	907	281	997	104	467	124	799	229	035	594	293	489
748	141	746	658	703	545	491	234	512	498	436	557	313	081
088	377	613	153	825	052	206	329	673	890	366	759	111	337
080	290	703	945	365	149	084	615	929	278	088	345	299	480
072	062	978	932	691	969	693	737	230	504	426	783	579	830
612	259	346	509	394	223	210	319	721	035	103	166	735	484
452	090	872	474	026	527	917	805	391	196	539	273	571	636
535	945	723	151	557	610	458	929	268	371	713	056	249	602
713	875	808	372	687	847	096	976	984	405	652	349	055	471
956	451	141	639	435	031	462	663	336	324	381	644	854	658
572	678	386	377	543	892	055	944	370	832	876	407	320	829
052	815	053	866	394	216	787	867	447	125	400	117	311	324
286	422	843	571	031	684	085	724	299	431	989	481	107	900
591	447	809	133	860	290	544	209	671	861	912	005	824	839
087	808	481	999	180	645	870	511	085	440	847	337	738	233
857	003	057	284	736	687	810	187	557	708	134	423	584	956
248	719	756	712	124	679	975	608	754	084	785	137	072	344
679	659	231	171	450	896	762	591	215	514	709	005	349	642
033	035	782	839	736	591	203	630	521	097	560	255	114	794
872	065	308	496	206	044	655	062	279	323	819	189	769	567
394	319	647	304	110	487	480	477	822	781	967	997	467	556
058	867	002	213	569	524	698	081	114	334	433	260	357	430
934	728	019	419	838	993	012	966	161	385	145	420	682	227
723	755	314	358	977	656	065	964	668	003	574	336	205	125
966	541	860	340	470	859	885	210	426	947	045	838	515	742
786	765	244	588	160	868	983	086	224	566	336	334	521	700
515	355	762	225	175	232	619	922	819	173	881	935	714	192

32

476	474	569	014	082	327	381	242	636	943	194	434	060	611
592	867	885	798	815	053	795	086	143	407	216	078	311	774
609	232	970	554	886	563	760	635	221	225	417	499	104	744
440	926	781	119	775	828	048	958	816	177	561	122	076	539
268	147	579	978	640	080	915	145	762	869	510	414	956	136
779	799	954	151	554	263	910	769	412	094	455	426	733	648
791	665	621	296	550	985	684	237	749	009	597	370	825	186
209	665	900	614	306	719	327	772	465	130	141	209	820	854
277	788	871	684	788	745	235	778	569	771	920	982	978	912
814	697	864	419	910	033	630	496	830	268	566	504	780	002
526	289	630	809	064	808	412	543	667	502	358	948	509	324
626	924	949	478	432	529	049	128	713	273	135	759	788	846
452	684	212	340	456	571	803	919	164	573	992	088	389	650
342	438	209	409	813	640	436	050	284	227	364	304	513	188
339	248	837	796	535	456	385	985	084	167	111	182	268	888
558	750	899	284	901	164	240	746	812	810	831	119	432	929
740	765	219	337	588	581	867	195	682	585	448	993	180	693
569	801	439	273	465	444	426	793	336	156	915	664	135	778
146	327	952	543	384	135	923	380	730	159	553	985	866	965
193	171	865	386	225	808	918	085	547	261	281	903	796	274
292	047	220	386	932	772	035	229	534	339	599	683	463	475
558	211	773	609	447	911	567	263	294	766	059	793	535	169
838	792	552	795	269	876	883	301	828	452	601	888	882	868
507	908	278	779	770	763	177	963	353	260	698	769	995	833
602	541	134	503	387	399	217	339	989	985	140	443	819	566
860	944	908	273	325	996	006	096	176	922	038	863	670	724
698	028	991	446	304	096	862	091	085	888	467	299	978	093
498	329	673	729	402	178	944	625	074	969	154	527	778	197
535	936	238	826	067	093	501	572	045	519	448	444	178	084
613	595	523	378	668	373	538	064	706	519	883	898	905	507
344	111	915	057	547	289	994	208	760	987	300	603	852	240
212	768	939	088	949	915	155	448	651	250	451	842	725	507
268	240	473	674	832	999	949	420	586	476	588	670	107	631
685	303	749	701	859	317	738	284	276	657	351	633	023	126
487	648	326	297	369	150	574	784	814	633	410	743	257	463
660	508	070	859	476	310	849	540	359	229	409	992	596	624
873	110	063	705	144	406	798	801	178	329	606	882	098	570
056	522	890	742	709	514	086	831	756	457	947	508	379	127
418	903	428	954	047	268	451	128	111	497	770	175	785	808
521	245	641	204	574	344	004	750	613	516	909	715	860	631
474	129	729	017	015	181	101	526	230	339	086	938	052	488
185	484	358	587	342	496	170	293	980	033	469	858	225	535
321	852	761	350	765	688	541	562	392	320	990	429	249	520
568	715	254	277	633	192	478	942	174	907	821	905	705	606
580	301	143	563	399	233	954	860	301	648	349	764	995	811
604	999	784	193	675	843	750	482	247	779	957	597	142	063
515	531	947	087	611	932	045	219	812	221	714	397	485	978
370	507	268	406	857	129	172	830	730	509	989	898	709	330
991	189	271	890	263	896	895	182	104	183	367	399	837	013
731	577	962	893	711	384	607	232	939	758	274	768	104	387

062	579	363	968	176	814	265	904	564	049	481	991	699	118
813	488	003	199	071	417	001	106	972	425	596	916	315	033
803	612	228	404	267	470	203	380	646	986	587	241	429	691
214	270	953	022	354	480	134	687	221	277	137	567	682	718
720	784	260	399	997	156	197	119	156	834	062	277	619	585
352	953	359	493	147	270	521	578	863	304	953	012	860	225
907	257	950	241	901	116	368	515	017	413	328	281	583	826
930	935	872	110	916	516	854	134	137	637	144	705	628	870
866	261	611	025	528	958	367	933	550	962	296	729	578	456
187	172	771	557	548	335	026	480	763	972	485	831	784	138
030	366	858	363	730	647	333	346	240	136	812	347	102	908
195	523	232	515	204	184	067	501	981	502	527	354	365	327
277	613	452	994	496	870	932	823	446	039	271	707	151	958
866	611	936	816	918	949	035	382	173	273	285	289	544	232
002	140	032	109	615	197	151	159	611	549	382	595	453	690
730	306	143	898	108	630	968	600	132	629	128	927	892	030
607	684	039	601	233	807	168	299	069	161	485	813	683	493
142	529	907	435	231	471	249	810	219	290	653	209	226	317
092	369	008	875	861	199	691	495	258	519	947	108	282	567
199	114	901	850	610	007	827	225	020	853	890	642	642	004
866	236	095	249	861	449	519	595	486	754	006	261	167	869
554	825	975	506	690	619	689	027	271	182	421	993	235	138
422	192	103	341	431	680	461	311	632	390	758	474	423	643
566	070	433	466	603	616	475	972	232	152	515	431	978	990
426	817	670	536	197	304	782	938	195	031	146	302	731	333
488	988	765	445	029	659	657	168	110	249	778	528	444	528
154	652	594	144	835	912	602	707	200	064	488	380	700	844
409	252	900	236	175	766	923	814	559	549	486	042	533	782
593	915	159	038	718	511	407	059	012	069	059	110	977	384
241	020	362	419	820	940	315	544	334	896	646	530	370	226
154	913	047	222	608	227	568	184	417	184	633	780	696	039
246	539	831	463	646	964	729	908	335	570	965	963	592	641
027	497	554	749	290	387	498	442	302	927	008	318	753	983
429	094	006	868	453	474	439	345	673	020	552	313	408	782
496	539	295	555	863	374	334	153	866	987	111	274	015	580
870	620	094	804	909	978	758	208	849	173	995	664	347	772
231	556	549	314	090	556	199	399	929	133	495	100	363	575
755	373	680	110	443	924	553	924	721	666	699	026	784	259
858	133	790	121	461	750	505	008	512	608	017	281	434	187
936	927	779	432	494	073	081	626	945	039	708	431	509	402
079	269	367	247	372	870	174	482	096	075	955	261	389	195
611	987	198	575	454	170	367	002	762	345	098	465	692	962
221	646	177	904	811	848	246	011	568	458	265	513	447	899
053	372	913	527	631	034	975	065	354	542	848	449	961	456
858	019	867	847	007	105	354	009	627	657	744	639	257	599
485	042	143	753	492	903	296	872	968	111	572	139	719	450
775	872	731	706	411	821	813	842	524	401	587	442	736	739
272	959	741	686	426	414	844	037	114	890	684	412	288	866
249	702	661	422	019	613	482	325	125	515	405	425	482	790
334	855	051	002	400	557	609	822	428	361	427	797	100	484

Once you have decided on how large a sample to draw, just follow these step-by-step instructions.

⊠ Drawing a simple random sample

> If you have a complete list of the population, here is how to draw a simple random sample:
>
> 1. Assign a number to each person on the list you wish to sample.
> 2. Choose numbers from the table of random numbers for your sample equal to or less than the total population size. (Example: If the population has 527 people listed, then any randomly selected number from 001 to 527 is acceptable.)
> 3. Locate the person on the list who corresponds to the random number you have just chosen.
> 4. Repeat Steps 2 and 3 until you have randomly selected as many people as you need for your desired sample.
> 5. If you draw a random number that has already been used, discard it and try the next number in sequence.

34

However, if you need a relatively large sample from a complete listing of the population but do not want to spend the time drawing a simple random sample, the method of choice is the *systematic random sample*. These are much easier to draw when you have a long list or want a large sample. Here are detailed instructions for systematic random sampling.

⊠ Drawing a systematic random sample

> If you have a long list of possible respondents, simple random sampling is often tedious. There is, however, a perfectly acceptable alternative: *systematic random sampling*.
>
> 1. Choose any number (not from the random number table this time) less than or equal to the size of the population to be sampled. That number gives you a *start point*. (Example: If you have a list of 4,720 names, any number from 1 to 4,720 can serve as your start point.)
> 2. Calculate a *sample interval* by dividing the population size (4,720) by the desired sample size, say 200. Generally, this quotient will have a remainder (in this case, 23.6). Drop the remainder and use the whole number (here, 23).
> 3. Find the population unit associated with your start point by counting down the list until you reach the start point number selected in Step 1. That name is your first sample unit.
> 4. To find the next sample unit, add the sample interval to the start point. (Example: Say you selected a start point of 150. Add 150 to the sample interval—in the example from Step 2, it is 23. The sum of 150 + 23 = 173. That is the location of the second name on the list to be included in the sample.)
> 5. Repeat Step 4, using the new location plus the sample interval to find the next sample unit for inclusion. (Example: 173 + 23 = 196.)
> 6. Continue this process until you have gone through the entire list and back to your start point. This procedure usually gives you a sample that contains a few more names than you want—this is a function of the *rounding* in the sample interval—but do not be concerned. Keep all the units you have selected. They have been randomly chosen and they may be used in getting your sample.

Now back to the decision tree. What if you do not have a list of the population you need to sample—a situation that is true for many arts settings, exhibits, and performances. You can still sample your audience population as if you had a list.

Just assume (and it is perfectly reasonable to do so) that the order in which people arrive at a performance or enter a museum puts them on a list, with the first person to arrive being listed as number 1, the second arrival as number 2, and so on. You can then plan to hand a questionnaire to a predetermined number of arrivals, chosen by systematic random sampling. Here is a step-by-step method for systematic random sampling of an unlisted population.

⊠ Sampling an
unlisted population

35

If you can assume that the order of arrival or departure determines a person's number on a list, then:

1. Assign the first person to arrive the number 1; the second, the number 2; and so on.

2. Estimate how many people are likely to arrive (or depart).

3. Calculate a sample interval by dividing the estimated number of arrivals by the size of the sample you wish to draw. (Example: If you estimate that 2,500 people are likely to attend an open-air concert and you want to sample 500, then divide 2,500 by 500, giving a sample interval of 5.)

4. Choose a start point. Some small number between 1 and 100 will do fine.

5. Start counting with the first person to arrive and interview the arrival whose number corresponds to the selected start point.

6. Keep counting subsequent arrivals, adding the sample interval to the start point. When the person whose number equals the start point plus the sample interval arrives, interview him or her. (Example: Say you have chosen a random start point of 51. Further assume that your sample interval is 5. Then $51 + 5 = 56$. So you will want to interview arrival number 51 first and then arrival number 56.)

7. Continue adding the sample interval as in Step 6 until all attenders have arrived (or departed) and you have filled the sample design.

And what if you cannot assume, as in the case of an open-air setting, that people will arrive through a single entrance or array themselves into orderly patterns? In that situation, the decision tree leads you to a consideration of *multistage sampling*.

A multistage sampling strategy is in order when the attendance varies a great deal because of some factor such as time or date or location, and you have little or no idea how those factors will affect your findings. The point in multistage sampling is to make sure that the variations are accurately reflected in the sample drawn. Do people who go to a museum during the week, for example, differ from weekend goers? If you suspect they do, then you might want to draw a multistage sample with days of the week as a sampling unit. *Station sampling,* where you assign numbers to each important exhibit area and then sample both ''stations'' and people, is yet another example of multistage sampling.

⊠ How to draw a multistage sample

> If your situation calls for a more complex sampling design known as multistage sampling, here is how to draw that kind of sample:
>
> 1. Decide on your sampling unit (e.g., exhibits, stations, days, times of day).
>
> 2. List every sampling unit and assign numbers in sequence to each unit. (If you use times of day as sampling units, it is often a good idea to divide time into relatively short units of from five to fifteen minutes.)
>
> 3. If the number of sampling units is large, draw a simple or systematic random sample from the list of sampling units.
>
> 4. Within each sampling unit chosen, randomly select the people who will make up your sample. Draw an equal number of people from each sampling unit. (Example: If you wanted a sample of 1,000 people and you had 25 sampling units, say exhibits, you would draw a sample of 40 people from each of the 25 sampling units. If there were 50 exhibits, you would select 20 people from each of the 50.) The people to be selected can be chosen by either simple or systematic sampling depending on conditions.

In this chapter, we have introduced you to the complex world of sample design. We have not covered all possible designs; there is, for example, an important one called *stratified sampling*, which we have not included. Stratified sampling is appropriate when you have some reason to believe that your study population of arts attenders falls into natural groups or strata (e.g., rock concert goers, opera buffs, jazz fans) and you want to compare answers from these strata. Another use for stratified sampling is to get answers to a questionnaire from enough of the purchasers of each of the different price levels of tickets so that the responses from each group can be compared with the others and at about the same level of accuracy. But stratified sampling is an especially complicated task, and we recommend that you seek professional advice if you think your research could benefit from it. Indeed, seeking qualified advice is the continuing theme and final point of this chapter. If you follow the rules we have provided, you will be able to draw most of the samples you need. But if you have any doubts, or are just getting started in the survey business, get professional help. Sample design is simply too important to leave to chance.

Honoré Daumier: Un guichet de théâtre. *Wood engraving, 1862.*

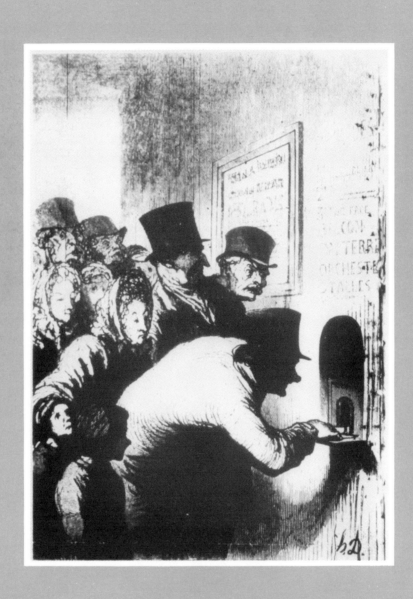

IV.
Collecting Survey Data

□□□□□☒□□□□□□□☒□□□□□□□□☒□□□□□□□□☒□□□□□□□□☒□□□□□□□☒□□

39

Once you have decided what you need to ask your audience and how to sample, the next step is to decide how you are going to get the information. There are a number of possibilities: self-administered questionnaires, in-person interviews, telephone interviews, or direct observation. Each has its strengths and limitations, and some are more appropriate than others for studying various arts audience situations.

This chapter outlines the basics of survey data gathering. To avoid an unnecessarily abstract discussion of research methods, we will tie our discussion to data gathering in specific arts settings. By the end of the chapter, you will be able to choose the method that will satisfy your needs, and you will know how to field a successful survey.

The self-administered questionnaire

Distributed either in person or by mail, the self-administered questionnaire is the easiest and the least expensive way to collect survey data. Why? Because the respondent acts as his or her own interviewer, reading the questions and filling in the answers with little or no assistance. What that means is substantial savings in time, money, and effort that otherwise would have gone into the training, hiring, and supervision of professional interviewers.

The challenge in collecting data by this method is to construct a visually appealing, concise, and self-explanatory questionnaire—a survey instrument that people will complete and return. Self-administered questionnaires that are distributed and collected on site should probably consist of no more than about twenty-five questions since most people will not take the time to answer more. By contrast, a self-administered questionnaire that is mailed to respondents' homes can run longer (fifty questions are not uncommon) since people at home are more likely to take the time to answer your questions.

Honoré Daumier: Le couplet
final. *Wood engraving, 1862.*

⊠ Designing a mail survey

⊠ Improving responses
to mail surveys

Getting people to fill out a mailed questionnaire takes planning and careful design. Assuming you have a list of potential respondents to whom you will mail your survey, here are some things to keep in mind:

1. Always include a cover letter with your questionnaire. The letter should explain who is making the survey, why it is a useful study, and why the respondent's answers are important to the success of the survey.

2. In designing the questionnaire, remember that appearance counts. Use lots of white space. If possible, have the questionnaire set in an easy-to-read typeface and printed on heavy paper.

3. Keep the questionnaire short. A one-page form is best, but if you must ask more questions print the questionnaire in brochure form. Four pages, front and back, is generally the maximum length questionnaire that the public-at-large will complete.

4. Use arrows to guide respondents from one question or block of questions to the next. Be extra clear when using filter or skip-pattern questions. Some people will have trouble knowing how to deal with them.

5. Do not put numbers—codes or column identifications—on the questionnaire. They will only confuse the respondent. It is all right, though, to put a respondent identification number on the first page of the questionnaire. Most people realize that you must keep track of the questionnaires and will not refuse to complete the survey because of the I.D. number if you promise to keep their answers confidential.

6. Include a stamped envelope with the survey materials so that respondents can send the completed questionnaires back to you.

If you decide to go the mail route, be prepared to make follow-up mailings

Whenever you conduct a mail survey, it is imperative to send out follow-up mailings reminding people to complete and return the questionnaires. Without follow-ups, the response rate for a mail survey is likely to be unacceptably low. Plan for at least two follow-ups. Three is better.

First follow-up: One week after the initial mailing of your survey send a postcard reminder to all potential respondents. The postcard should thank people if they have already returned the survey and courteously urge nonrespondents to complete the form. The postcard should also offer to replace any misplaced or lost questionnaires.

Second follow-up: Three weeks after the initial mailing send a replacement questionnaire and new letter to all nonrespondents. The letter should be courteous but insistent. Remind the respondent that the study is important and may possibly have some direct benefits for him or her. Reiterate the need to have everyone's opinion.

Third follow-up: If the response rate to your survey is still low, say, under 60 percent, then you ought to consider a third follow-up. Wait until six weeks after the initial mailing to make this decision. If you go for a third mailing, send out yet another copy of the questionnaire and a cover letter that points out how many others have already replied. If you can afford it, send this last package by certified mail—this will suggest its importance.

It is relatively easy to keep track of who has returned a questionnaire and who has not; simply assign a number to each potential respondent on your list and put that same number on the questionnaire you mail them. Most people will not even notice the identification number and even fewer will view it with suspicion.

In short, the self-administered questionnaire is a comparatively inexpensive yet effective way to collect survey data. Questionnaire design, printing, postage, and follow-ups will, of course, require a budget. But these costs are considerably less than those associated with other data gathering methods.

The personal interview

In-person interviewing is the most effective way to collect large amounts of detailed data about the arts audience. Unfortunately, it is also likely to be the most difficult, time-consuming, and expensive approach.

Most people interviewed in their homes are willing to spend half an hour or more answering your questions. If you are conducting in-person interviews with people attending an event, however, do not expect them to give up more than ten minutes.

Personal interviews demand highly skilled interviewers. Professional survey and marketing firms have that kind of expertise but may charge fifty dollars or more per interview plus travel and other costs. Your own staff or volunteers can be trained to conduct in-person interviews, and that will save you money. However, volunteer interviewers must be closely supervised in order to maintain the quality and integrity of your survey.

Interviews by telephone

The telephone interview is probably the most common survey technique today. Telephone interviewing falls about midway between the personal interview and the self-administered questionnaire in terms of quality of information and cost effectiveness. A well-designed telephone survey can take as much time as an in-person household interview and can yield satisfactory proportions of completed interviews.

Questions for telephone interviews must be relatively straightforward because it can be difficult for respondents to comprehend complex questions heard over the phone. When telephoning, it is crucial that every effort be made to contact the person or household designated in the sample. You should try at least three times to make contact—at different times of the day and on different days of the week.

In planning a telephone survey, do not forget that you will need a battery of telephones. Unless you can get sole use of half a dozen or so existing phone lines for the duration of your survey (up to a month or more is not uncommon), you will have to arrange for extra phone lines. You will also need enough interviewers to cover all the phones for the hours you plan to call (usually some daytime hours, like 10:00 a.m. to 2:00 p.m., from 6:30 p.m. until 9:30 p.m., four or five nights a week; and perhaps weekends, too).

The major problem with telephone arts surveys is how to get the phone numbers of members of the arts audience unless a list of attenders' phone numbers is supplied. Asking attenders to write down their numbers for you introduces all sorts of sample biases. Are the people who volunteer their numbers those who are

most supportive of your museum or theater company, or are they the least satisfied and want an opportunity to complain? Since it is almost impossible to know what motivated them to respond, it will be difficult to interpret your findings. In short, the telephone probably has utility only for gathering data about arts attenders where names and telephone numbers are on existing lists, such as the membership of your museum or your season subscribers.

Community studies and the nonattenders

There may come a time when you will want to know more about the people who are not already in your audience. Getting this information can be complex, but it can have substantial pay-offs in terms of outreach and improved community relations. If you are beginning to think about conducting a study of nonattenders, what you are really thinking about is a survey of your entire community.

Surveying an entire community (usually a geographic area defined by political boundaries such as a city, county, state, or the U.S. Census Bureau's Standard Metropolitan Statistical Area) presents enormous difficulties for most arts organizations. In fact, we would strongly urge most arts organizations not to undertake community surveys on their own. Fortunately, there are some alternatives. Arts organizations with significant financial resources can use outside consultants or polling firms to conduct the surveys for them. For an arts organization with a limited budget, one possibility is to buy into an *omnibus* survey. A growing number of universities have survey research centers that regularly conduct regional, county, and metropolitan polls. In omnibus surveys, a group of clients sponsor a poll with each sponsor paying for a small number of questions of special interest. Each gets the answers to these special questions as well as answers to a set of common questions, usually about respondent demographics. An arts organization that bought three or four special questions priced at several hundred dollars each could receive reliable data targeted at specific needs together with all the general information that is collected.

Observation as a data source

Some data about arts audiences, particularly in exhibit settings, can be gathered by direct observation. Observers can be trained to count people and to make reliable judgments about their characteristics. For example, observers in a museum setting could gather data that would answer such questions as: How many people stopped at a given exhibit? How long did they look at the exhibit? Did they interact with the exhibit? At what time of day did the people visit the exhibit?

Such audience characteristics as sex, approximate age, physical handicaps, and the like can be gauged quite reliably by observers who have had only a little training and some supervised practice. Other characteristics (education, income, and race, for example) are much more difficult to observe.

Finally, note that observations may or may not be based on a sample. If the number of people you plan to observe is relatively small, say under 500, you probably will want to record information about them all. If the population you plan to observe is more than 500, say all the people who stop in front of a given exhibit over several days or weeks, it probably would be wise to use a multistage sampling strategy (see Chapter III) to choose the time and places to make your count.

Now that you have a sense of the different methods for collecting data, let's apply those techniques to some specific arts settings.

The Audience Setting. In an ideal world, the personal interview is always the first choice for data gathering because it is most likely to yield information of the highest quality. Unfortunately, audience settings do not easily lend themselves to personal interviews. Since the entire audience enters and leaves the theater or concert hall at approximately the same time, a huge staff of interviewers would be necessary to survey even a small sample of attenders.

A mail questionnaire or even a telephone survey may be a viable alternative—if you can develop a complete listing or directory of the audience. If you want to survey, say, season subscribers, it should be easy to obtain a list of their addresses and perhaps even telephone numbers. Without such ready-made lists, you might be tempted to compile one from the audience. It would be relatively easy to put a preprinted three-by-five-inch index card in every program and ask your audience to fill in their names, addresses, and phone numbers during intermission. *Don't do it.* You will be lucky if half the audience fills out the card. That means you will be missing addresses or phone numbers for 50 percent or more of the audience, and it also means that you will have no way of knowing whether the people who filled out the cards are representative of the entire audience. Even if you tried to survey those people who did fill out cards, you would not be able to reach all of them, and that would further reduce the overall response rate, making your survey just about useless because of the unknown bias.

What then is the method of choice for surveying in the audience setting? Given the financial and staff limitations of most arts organizations, and taking into account the peculiarities of the audience setting, the self-administered questionnaire is usually your best bet. As a data-gathering method, the self-administered questionnaire is relatively easy to carry out, is comparatively inexpensive, and, if you follow some simple rules, can produce usable results.

First, the questionnaire has not only to look short but be short, about twenty questions or whatever attractively fits on both sides of a single sheet of paper. Avoid the temptation to photoreduce the questions to squeeze more onto the page. Provide a small pencil along with the questionnaire.

Second, make your instructions brief but clear. Explain: (1) that only the person who received the questionnaire should fill it out—no group judgments, please; (2) when to fill out the questionnaire—before the performance, during intermission, after the performance is completed; and (3) how to return the completed questionnaire—give it to an usher, put it in the red boxes, etc.

Third, make a special effort to collect the completed questionnaires. Have return boxes prominently displayed; also have your staff move through the audience asking for completed forms. Printing the questionnaires on brightly colored paper will make it easier for your staff to spot them.

Fourth, follow your sampling plan (Chapter III). In general, the easiest sampling plan would be a survey of the audience at a single performance or a sequence of performances. If your organization is particularly large or already somewhat

knowledgeable about your audience, you may want to use multistage samples based on days, series, and attenders. However, regardless of the sample plan, you will insert the questionnaire into the program or playbill. You don't want your questionnaires knocked off seats onto the floor or jammed into coat pockets, so the program or playbill will help to ensure that questionnaires are not lost or discarded.

All in all, the self-administered questionnaire is appropriate and well-suited to the audience setting. The actual distribution and collection of the survey does not demand highly trained interviewers. And if you follow our guidelines you should get good results. What this means, among other things, is getting back a sufficient proportion of the questionnaires so that unknown biases do not creep into the survey results. While your staff and volunteers do not need to be highly trained at interviewing when using a self-administered questionnaire in an audience setting, they do need to be diligent and persistent with a large measure of charm. There is no tomorrow for follow-ups in the audience setting and, if an insufficient number of completed questionnaires is returned, your survey will be ruined.

The exhibit setting. Art exhibits have unique characteristics that play an important role in determining how information is collected from exhibit viewers. For example, because there is no tightly scheduled time for attendance, distributing questionnaires and maintaining the sampling plan become somewhat of a problem. On the other hand, this lack of a fixed timetable can work to your advantage, since exhibit goers usually have five extra minutes or so to answer your survey questions.

Telephone interviews generally do not work in an exhibit setting because of the obvious problem of obtaining a complete list of attender telephone numbers. You may, of course, ask for people's telephone numbers as part of a self-administered questionnaire or personal interview. Having these numbers would allow you to do follow-up or trend studies with the *same* respondents you have just interviewed. Remember, though, if you ask for a phone number, you must also figure out ways to protect respondents' privacy. One good method is to keep personal information (name, address, phone number, etc.) separate from the completed questionnaire. An identification number can be used to link the two sets of information.

The self-administered questionnaire and the personal interview are both well adapted to data gathering in exhibit settings. Personal interviews may yield higher-quality data, but they will do so at considerably greater cost and effort. Still, we cannot emphasize strongly enough the importance of trained interviewers for both methods. In an exhibit setting, interviewers play an active role in the sampling plan (they must count attenders and interview every *n*th one) and they must be able to get completed interviews. Accomplishing those two tasks takes both practice and savoir faire. In fact, it is often a good idea to separate staff into samplers, who count and identify potential respondents, and questioners, to whom the samplers lead potential respondents.

By contrast, gathering data by self-administered questionnaire requires fewer interviewers, since they would really only need to be trained in carrying out the sampling plan. Unlike the personal interview, there is no need for a one-to-one relationship between respondents and interviewers. Still, it is a good idea to have a member of the survey staff in the vicinity of the respondents as they fill out

☐ Exhibits

questionnaires. That way you can answer any questions that might come up, prevent the sampled individual from providing group answers, and make certain the completed questionnaires are returned.

Sampling in exhibit settings presents a manageable challenge. Your sampling plan must clearly define the population to be sampled and you must be certain what it is you need to know from the survey. Do you, for example, want to include education tour groups in your sample? And what about people who visit during the week as opposed to weekends or at odd hours? You must also take into account the kind of information you want to collect. For example, if you want to know what visitors thought of your newest blockbuster exhibit, you have to make sure you get a sample of people who saw it and not just a sample of people who have entered the museum.

Sampling in an exhibit setting often calls for a multistage sample or even a stratified design (Chapter III). In general, though, if you carefully define the population to be surveyed in the exhibit setting, and if you think of passing exhibit viewers as a list to be sampled, you should be able to collect the data you need.

The open-air setting. Lacking clear boundaries of time and space, the open-air setting is an especially difficult place to conduct a survey. It is, however, also more casual and informal. People seem friendlier, more relaxed, and may be more willing to answer survey questions. Still, conducting a survey of an open-air audience requires careful attention to data-gathering techniques and to sampling design.

As to data gathering, telephone interviews or mailed questionnaires are feasible only for a follow-up study of the free-admission open-air attender. Since no listing of the audience exists, you would have to create a list by asking members of the audience to provide you with the appropriate information. But if you take the time and effort to get names, addresses, telephone numbers, etc., of a sample of the audience, you might just as well take a few minutes more and ask your questions.

The self-administered questionnaire is also impractical for the open-air setting. There are simply too many distractions at most open-air settings, and it is too easy for the potential respondent to throw the questionnaire away or stuff it in a pocket. If your budget is so limited that the self-administered questionnaire is the only method you can afford, you should distribute a self-addressed, stamped envelope with each questionnaire. Combined with personal distribution of the questionnaire, the return envelope modification will at least let people know how to return the completed questionnaire. Still, do not expect a very good response rate from this method. In fact, be prepared for a rate that may be so low it invalidates the results.

In most cases, the preferred method for data collection in open-air settings is the personal interview. The personal interview is the only way to guarantee getting completed interviews from the selected respondents in your sampling plan. Interviewers for the open-air survey need to be especially well-trained. For instance,

☐ Open-air setting

the interviewer will be responsible for implementing the sampling plan and choosing potential respondents. The interviewer will have to be adept at asking people to take part in the survey. It is often difficult to interrupt people or to isolate one member of a passing family or group. Interviewers represent your organization to the public; prepare them to handle all situations efficiently and tactfully.

Sampling an open-air audience is always a perplexing problem. When admission is free, it is especially difficult to define the population to be sampled. Often several activities occur simultaneously. For example, a concert presented near a sidewalk exhibit could be sampled for concert goers, concert goers who also attended the exhibit, and concert goers who might not have seen the sidewalk exhibit. Given such complexity, it might be wise to try a simple study first, taking each of these activities separately. That way you will learn if you need a different kind of questionnaire or a different data collection method.

Having defined your population, the next problem is how to select the respondents called for by the sampling design. Keep in mind that anyone—attender or nonattender—could be walking through the open space where your arts activity is going on. That fact alone makes it highly unlikely that you will ever get a really good probability sample in an open-air setting. But there are some things that you can do to maximize your chances for getting a satisfactory sample. In many instances you can think of the attenders as if they were in a more traditional setting, such as a concert hall. Just keep in mind that they are not really in the more conventional setting and evaluate your data accordingly. That is, in a concertlike setting you could put a copy of your questionnaire in every program or playbill. Anyone who takes a seat becomes a potential respondent. In the open-air setting, have your staff distribute questionnaires to everyone who is seated at the time a given piece of music is played or during an intermission. Watch the ebb and flow of the audience, how many people arrive and depart and when. That will help you estimate how the sampled attenders relate to and differ from the entire set of attenders. Have your staff wander about asking for completed forms; this will encourage people to fill out the questionnaires. Do the best you can and do not forget to provide pencils.

For sidewalk exhibits or sales, use the multistage sampling design described in Chapter III. If you have a lot of exhibits, or if you think some people might be overlooked with just a few sampling station locations, consider using more stations. When surveying stations or exhibits, select respondents after they have viewed the particular exhibit—that way you know they are definitely part of the population you want to study. Do not interview people who voluntarily walk up to the interviewer; they are not likely to be representative of your audience. Stick with your sampling plan. When things get really busy, it often becomes difficult to interview the designated respondent, so make sure to have enough interviewers— that way no designated respondents will get away. And finally, have your interviewers practice the sampling method (the choosing of every *n*th person) by going to a busy intersection or shopping mall and conducting a small-scale pretest of the survey.

Survey interviewing is part-time, short-term work with long hours, often at odd times of the day. Interviewing is often hard and intense. It also is a critical factor in the success or failure of a survey. Of course, if you have the money it is possible to hire trained interviewers from a survey or marketing firm. But if you have decided that the only way you can afford the survey is by using volunteer interviewers, allocate more than enough time to choose, train, and supervise the people who are taking your study into the field.

Starting about six weeks before the actual survey dates, the first thing you do is to decide how many interviewers will be needed. The number depends on (1) what the interviewers will have to do and how long it will take to complete an interview, and (2) how many days or weeks you have to complete all the interviews. It is not always easy to know in advance how much time any one interview will take, but you can make an estimate. It is definitely better to have too many interviewers and get the job done faster than to have too few interviewers and not be able to complete the sample plan. Also, selecting and training more interviewers than you need allows for dropouts, a very real possibility if you are using volunteers.

Plan to spend two to three weeks locating potential interviewers. It is a good idea to have your interviewers selected by the time the questionnaire is back from the printer so that you can train them with the actual survey instrument. If you are lucky enough to have a group of volunteers who work regularly with your organization, that is the first place to look. Most communities have service organizations whose members might be interested in helping out; college students are another good source of interviewing talent.

In general, women make the best interviewers. For better or worse, most people are more at ease and feel less threatened if approached, either by telephone or in person, by a woman. Of course, men can be excellent interviewers, but they must be warned about the possibility of being perceived by some people as threatening. A good interviewer is neither overbearing nor passive, neither intimidating nor so unobtrusive that he or she can be ignored. It is a difficult balance to achieve, but it can be done. For personal interviews, each member of your field staff should have a pleasant appearance and a clear speaking voice. In bilingual communities, at least some of the interviewers should be bilingual. In choosing an interviewer, select someone who can follow instructions carefully. Common sense is more important than a college diploma.

When talking with potential interviewers, you must explain what is expected of them so that they will know whether they want to take on the job. At the same time, you should try to decide whether that person is right for your survey. Prior survey experience is a plus but no guarantee of good interviewing skills. Applicants who say they like to talk to people may be too chatty. Ask the potential interviewer to write down his or her name, address, and phone number on an index card. Is it legible? If not, you probably won't be able to read that interviewer's handwriting on the questionnaire. Make it clear to a potential interviewer that if he or she is not

comfortable conducting interviews, the respondents will not be comfortable either. Most people know if they can cope, and those who are least likely to cope will bow out.

Having selected your field staff, the next step is to train them. A training session can last from a few hours to several days, depending on the complexity of the interviewers' role in the survey. Always plan more training time than you initially think will be needed. It is time well spent since the interviewers can make or break your survey.

Begin the training session with a short presentation on why the survey is being done and what your organization is hoping to learn. Include a brief overview of the whole survey process so that the interviewers can see how their efforts fit into the total scheme of things. From the outset, it is important to stress two overriding concepts: confidentiality and objectivity. In the context of survey research, the former means making every effort to protect the confidentiality of a respondent's answers to your questions. By promising to keep answers confidential, survey researchers are able to get information from the public.

Objectivity covers a number of interrelated matters, many of which bear on how the interviewers do their job. The purpose of a survey is to find out what people think and do. In order to compare and contrast the respondents' answers, it is necessary to be sure that everyone has had the same opportunity to answer the same questions under the same conditions. Unfortunately, interviewers can easily bias a survey by the way they conduct their interviews. To prevent bias, interviewers must adopt a neutral attitude. They must not appear to be judging the correctness or the social desirability of the answers they get. A good interviewer accurately and completely records what the respondent says, not what the interviewer thinks the respondent means. Additionally, an interviewer can bias the results by modifying the questions in any way. Survey questions must be worded exactly the same way every time they are asked, and speech inflections should not emphasize the importance of certain words or certain questions. It is all right, however, for an interviewer to define a term for a respondent if it is clear that the respondent would otherwise misinterpret the question.

Poorly trained interviewers often get sloppy and start misreading questions or streamlining them to speed up the interview. Alert your interviewers to this problem. By giving your field staff sufficient time to complete the survey many problems of fatigue can be avoided.

Open-ended questions present the biggest opportunity for the introduction of interviewer bias both in asking the question and in recording the response. All interviewers need to be warned against rewording the question or helping the respondent to answer, and interviewers must be trained to record the response word for word. Paraphrasing open-ended responses should never be allowed.

No interviewer should be permitted in the field without first participating in a practice session. These training sessions build interviewers' self-confidence and poise. They also give you the chance to correct mistakes, evaluate the skills of the interviewers, and anticipate problems that might arise during the actual survey.

The interviewer supervisor should be on site during the fieldwork. This is especially true at the very beginning of the survey, when last-minute questions will need to be answered and when the first few contacts with potential respondents will generate new questions. The field supervisor can look. listen, and correct interviewing errors before they become ingrained in the minds of the interviewers.

Questionnaires should have a space for the interviewer's name and the time and date on which the interview was completed. That will make it possible to discuss problem questionnaires with the responsible interviewer. We recommend that a separate large envelope or folder be provided for each interviewer's questionnaires. A simple check on the volume of work completed is a quick indicator of the interviewer's competence. It also gives you a sense of how the survey is going and whether the interviewers are doing as much work as you estimated they would when you determined the number of interviewers that would be needed.

It is important to tell the interviewers from the start that you will be evaluating their performance. Fortunately, the task of reviewing the interviewers' work and preparing the completed questionnaires for data processing and analysis can be done at the same time.

49

⊠ When to hire an outside polling firm

The premise of this manual is that arts organizations can learn to conduct their own high-quality surveys. However, there are times when it may be better to hire an outside survey or marketing research firm to give you a hand. Here are some examples:

Inadequate in-house staff–Since conducting your own survey takes internal staff and often volunteers as well, some arts organizations may lack these resources.

Need to survey a complex population–If your study requires an especially complicated sampling design, it is better to get the advice of a sampling expert. The larger survey and marketing firms often have sampling statisticians on their payrolls.

Interviewer problems–If you have not been able to recruit volunteer interviewers or do not have the time and resources to train your own paid interviewers, then it is far easier to turn to a polling firm or field staff organization for help. All large cities and many medium-size or smaller communities have such organizations.

Whenever you seek outside help, it is always a good idea to shop around. Get price quotes from several different firms. Ask about the reputation of the firm you are considering. Often local advertising agencies and university departments of sociology, marketing, communication, or journalism can supply that kind of information. One indicator of a highly responsible organization is membership in professional groups such as the American Association for Public Opinion Research and the American Marketing Association.

Beethoven's Ninth Symphony

V.

Data Processing

Editing and coding

51

As the completed questionnaires come back from the field, you should begin getting your data ready for processing and analysis. You need to convert the questionnaire responses into a form that can be counted. Unless you have a very small sample, say under 200 interviews, you will want to analyze the raw data by computer. Since computers cannot read handwriting or interpret the marks on a questionnaire form, survey answers must be coded in terms of numbers, which the computer can process. Before survey data can be entered or fed into a computer—on cards, tape, disk, or directly into the computer memory—they must be reduced to unambiguous numbers that can be keyed into machine-readable form. That process is known as editing survey data; both fixed-response and open-ended questions must be edited before data entry can occur.

Editing fixed-response questions. When a fixed-response question is designed, it is often a good idea to assign a code to each response. If the questionnaires are to be filled out by interviewers, print that precoded number on the questionnaire. However, don't print the precoded number on questionnaires that are to be filled out by the audience. Take the following example:

> How much did you enjoy tonight's show? (Circle the appropriate number.)
> 1—A great deal 2—Somewhat 3—Hardly at all

Respondents will choose one of these three possible answers, and either they or the interviewers will have circled the appropriate number. All you have to do to get the answer into the computer is punch or *key* a single number, from one to three. A fourth number is needed for no response to the question or for responses that cannot be interpreted, which leads to the next point.

Unfortunately, there are respondents and interviewers who do not follow instructions. When that happens, the survey editor has to decide what to do with the inappropriate answer. Here are some common problems and our best advice on how to handle them. The examples are based on the sample question about enjoyment of "tonight's show."

Multiple responses: Despite the instructions to circle one possible number, the respondent has selected two or more answers. If one or more of the responses has been erased or crossed out, and if you can tell which answer is the respondent's final choice, circle the final choice with a red pencil and tell the data-entry folks to punch it. If you cannot narrow the multiple answers down to a single choice, code this question as a *blank* or *no response*. Blanks or no-response answers are usually indicated by the number 9. The exact number you use does not matter. What matters is that you, the data-entry people, and the computer know what code is being used.

Adolf Dehn: Beethoven's Ninth Symphony. *Lithograph, 1929.*

"A great deal" to "somewhat": One of the most frequent inappropriate responses is the circling of two or more numbers or the placing of an *X* between two precoded answers. Since there is no way to tell what the respondent meant, the most conservative strategy would be to code this error as a *blank*, meaning "no response." On the other hand, it is perfectly acceptable for the editor to decide for the respondent. When making that choice, the editor should know how the data will eventually be analyzed and what implications the coding decision will have. In the case here, it might be best to make a conservative decision and code the response as "somewhat."

"It was well done": Say the respondent has not circled a precoded response but instead has written in, "It was well done." Clearly, it is not a negative response. So if the purpose of your question is to determine how many positive and negative answers you get, then you might reasonably code this answer as "somewhat," the minimum positive response. Alternatively, if you have other purposes in mind for the data, you could code this response into an "other" category. That has the advantage of retaining the suspect response in the overall total of sample responses.

There is, however, another possible interpretation of this respondent-written answer. What the person answering might have meant was, "It was well done for what it was, but I do not really like that sort of thing." Certainly that is a negative response and the level of enjoyment must be presumed to have been rather low. Indeed, based on other answers or other information about the respondent, you might want to put this response in a moderately negative category.

"I thought the choice of materials was very good": Here is another handwritten insertion. The respondent is addressing a specific aspect of the performance; but the survey question asks about the overall enjoyment of "tonight's show." In short, the respondent is not answering the question posed. Code this answer as "no response."

"If you mean . . .": The respondent has added his or her own qualifier to the basic survey item and then checked or circled one of the fixed-answer responses. Be aware that the presence of the qualifier modifies the question asked. In fact, the respondent probably did not answer the question you posed. Code it "no response."

In general, it is a good idea to keep track of the questions for which problems of this sort arise. Written modifiers or comments often indicate an ambiguous question or inadequate instructions. Future versions of your survey should take these comments into account.

Coding open-ended questions. By definition, open-ended questions are coded after the survey is completed and all the questionnaires are in hand. In coding open-ended questions, you are trying to reduce the verbatim answers of the

respondents to a set of simple number codes that the computer can process. These codes must be:

Exclusive—every response should fall into only one coding category.
Exhaustive—codes should cover all important distinctions, and answers that fall into a miscellaneous or "other" category should be kept to a minimum.
Useful—codes should simplify the handling of open-ended responses without reducing your ability either to interpret the results or make policy based on the findings.

To prepare the coding scheme for a given open-ended question, first read a large number of the completed questionnaires, say 10 to 20 percent for samples larger than 500 respondents and no fewer than 50 for any size sample. For the question you are dealing with, write down the key phrases, concepts, or words that the respondents use. Keep a rough count of the repetition of these phrases or concepts. Look for patterns of similar, repeated responses. Finally, set up, write down, or work out categories that reflect the most frequent or relevant kinds of answers and then assign a unique numerical code to each category.

In general, there is no fixed limit on the number of categories that you can code. For most questions, six or seven should do quite nicely. Include an "other" or miscellaneous category as a catchall, but be careful that "other" does not go above 5 percent or so of the total responses. If it does, you may need another specific category to code the most frequent of these.

Once you have a preliminary coding scheme, hand the coding instructions to two or more coders and ask them to code a dozen or more questionnaires. Give each coder the same set of questionnaires to code. Do not let them talk to each other about the coding. Then compare the answers. The codes should be identical or nearly identical. If not, the coding scheme probably is not detailed or clear enough and you need to talk to the coders to discover the sources of confusion. Revise the coding instructions and try again. Continue to test the coding instructions until you get nearly perfect agreement between coders. Then and only then is the coding scheme ready for use on the full survey.

Evaluating interviewers

Part of the information-gathering and editing process also involves the evaluation of interviewers. Important things to look for include poor handwriting, unclear indications of answers, and messy erasures. All can cause problems during data processing and all can be avoided if interviewers are careful and conscientious. Also, you will want to check that the interviewer has followed instructions, that multiple responses are not given where a single response was called for, and that the proper *skip pattern* is followed if the questionnaire has filter questions. Finally, check the amount of time the interview took. Interviews completed too quickly could mean the interviewer rushed the respondent; interviews that ran too long can mean the interviewer was not well enough prepared and was unfamiliar with the survey or had a conversation unrelated to the survey. Checking up on interviewers should help guard against interviewer bias in your survey.

It is possible to analyze the results of a survey with no more sophisticated tools than a stubby pencil and the back of an envelope. Indeed, if your sample is very small, say under 100 interviews, and if you asked fewer than a dozen questions, you may want to do a hand count of the results. However, most surveys of the type discussed in this manual do not lend themselves to hand counting. To analyze those results, you will need the help of data-entry personnel and computer programmers, and you will need access to a moderately large computer equipped with one or more of the standard programs for survey data analysis, such as the Statistical Package for the Social Sciences (SPSS).

At this stage of your project, it is best to shop around. Many different services and many different levels of expertise are available. In most college and university towns, and in cities of fifty thousand or more, there are data-processing services that can provide skilled data-entry and programming personnel. Highly skilled data punchers and programmers are often available at universities or through large businesses that sell their excess data-processing capacity. Some businesses may even donate these services to nonprofit organizations.

Data processing costs fall into three main categories:

Data entry: This involves taking the survey results directly from the questionnaires and converting the numbers into a form that the computer can understand. Data is punched (keyed) onto cards, disk, or tape. Assuming a questionnaire has twenty-five questions, it is possible for a trained data-entry clerk to punch at least 100 questionnaires per hour into the computer. For a sample of 1,000 interviews at 100 per hour and a pay rate for data-entry of $12 per hour, the data from a complete survey could be entered for approximately $120 (10 hours × $12 per hour). However, good survey practice calls for 100 percent data *verification*. To verify the data means repunching the entire set of questionnaires, comparing the first and second sets of data for inconsistencies, and correcting any inconsistencies that have arisen. Note that somewhat lower rates for data entry may be available from freelance data processors, and many data-processing organizations will charge a lower rate if they are involved in the entire data-processing operation.

Programmer costs: Once the data are ready for the computer, someone must tell the computer how they are to be handled, what manipulations to perform, and how to present the output. That is the function of the programmer, an individual who understands the computer and who can work with you to get what is needed. A typical rate for a freelance programmer is anywhere from $8 to $15 per hour. A commercial data processor may charge from $20 to $40 per hour for the same services, but computer time may be included in that price and a package deal might mean a lower rate. To set up the necessary computer files and to run the frequency distributions and cross-tabs (see Chapter VI) needed will probably require no more than a day or so of a programmer's time.

Computer time: Unless you have your own computer or have negotiated a package deal that includes computer or machine time, it will be necessary to budget some money for computer costs. Rates for computer time vary enormously,

depending on whose computer you are using. To run a 1,000-respondent survey of the type mentioned above will take approximately $200 worth of computer time based on 1984 costs of $300 per hour of computer memory (CPU) time. That would bring the total data-processing costs for the survey to something in the neighborhood of $500.

One final point. Always monitor the data-processing phase of your survey with special care, and keep a close watch on the company doing the data processing. Agree on a delivery schedule before you sign a contract. Your job probably will not be large and the data-processing firm may put it on a back burner while it works on a larger, more lucrative contract.

Schedule data entry and data processing one step at a time. Do not ask for everything until you have had a chance to inspect the results on a variable-by-variable basis. Check the first printouts carefully. Do any variables show values that were not coded or not allowed (for example, a 17 where you only coded 1 through 8). Maybe you made a coding error. Or maybe the data was incorrectly keyed. Or maybe the programmer misunderstood your data format instructions. If the data do not look right, say so promptly and have them checked.

Always remember, computers are idiots. They can do arithmetic very quickly, but that is all. They work because someone has told them what to do. Computers follow instructions, and sometimes the instructors make mistakes. Remember, too, that a well-designed table with many numbers looks impressive, but, unless the numbers that went into the computer are reliable and properly processed, that impressive computer output is worthless.

In sum, data processing is not complicated, but it does involve many steps, and it is crucial to the success of your survey that it be done accurately. If your arts organization does not have in-house staff with data-processing experience, get outside help. Only after this routine phase of your project is under control will you be ready to start the creative work of analyzing and reporting your results.

VI.

Interpreting and Presenting Survey Results

57

The final stage of a survey is the interpretation and presentation of the results. After that, it is up to the policymakers to decide what, if anything, to do. But before the action comes the data and analysis, and analyzing survey data is not everyone's idea of a good time. Some people are frightened by statistics or at least mistrustful of them. Working with survey data can be complex as well as challenging.

However, analyzing survey results need not be overwhelmingly difficult or unnecessarily distressing. For many purposes, you can do quite well with just two simple statistical techniques. The first is a frequency count, which involves little more than addition and long division. The second, much-used technique, called cross-tabulation, is not any more complicated than sorting and pairing socks.

In this chapter, we introduce you to the logic and practice of data analysis and present some hints on how to report survey results in a readable and action-oriented fashion. Of course, what you find here is only the beginning. If your survey can benefit from closer statistical review, you will need the help of an expert.

The frequency distribution

As a first cut on survey data, it is always best to take *frequency counts* or "frequencies" for each question; that is, count (by hand or by computer) how many times a given answer shows up for a given question. For example, suppose you wanted to know whether more men or more women attended your arts activity. Using the survey techniques outlined in this manual, you have interviewed a random sample of 400 people who, say, visited your museum. As part of the questionnaire, they were asked: "Are you female or male?" Two hundred twenty checked "female"; 180 checked "male." In this example, then, the frequency distribution is 220 women, 180 men, and this count of responses clearly suggests that more women than men visit your museum.

However, by themselves the numbers 220 and 180 are of only limited use. First of all, people are accustomed to thinking in terms of percentages, not counts or raw numbers. Second, what you really want is to say what proportion of your attenders are men or women and not just report counts from a survey. As a result, frequency distributions are almost always shown in terms of percentages rather than raw numbers. Consider the following table.

Sex of museum attenders

Question: Are you female or male?

Sex	%
Female	55
Male	45
	100 (N = 400)

It is based on the foregoing information, but the numbers have been recast in a more useful form. Reading the table is not difficult. It says that 55 percent of your arts attenders are women and 45 percent men. Where did those percentages come from? Easy. The total number of people sampled was 400, which is indicated by the entry (N = 400). The letter N is survey research shorthand for the total number of respondents. Dividing 220 (the total count of females) by 400 (the total number of people sampled) times 100 gives 55 percent. Similarly, the proportion of male arts attenders was calculated by dividing the 180 men by 400 and multiplying the answer by 100.

A few other details are worth noting since the table can serve as a model for presenting your own frequency distributions. First, the title *Sex of Museum Attenders* is short but completely descriptive of the table's content. Second, the exact wording of the survey question on which this table is based is also provided. Of course, people can look up the exact wording of the question in the appendix to your report, but it is more convenient to have the question attached to the data, especially the first time you discuss the findings. Third, the sex distribution of respondents is given in whole numbers (55 percent, 45 percent) and the distribution adds up to 100 percent. Whole numbers are precise enough for most purposes and do not imply a false precision about the result, which is, after all, subject to some error. Making sure the distribution adds to 100 percent tells your reader that nothing has been left out.

Follow this model table and the others presented throughout this chapter when you report survey results. It will make your study look professional, and if people who read the report find the data clearly presented they will be better able to judge the results.

☒ Checklist for reporting data in tables

1. Report results in percentage form. Actual frequency numbers are likely to be confusing.

2. Report the number of respondents on which the percentages are based. Use "N" for the total sample responding to the question (e.g., N = 657) and "n" for subsamples (e.g., n = 132). The "N" for most questions will be smaller than the total of questionnaires you receive because not all questions are answered.

3. Round off the percentages reported to whole numbers.

4. Make sure columns or rows add up to 100 percent (or the appropriate total). If the columns or rows do not add up to 100 percent, indicate in a footnote that the cause is due to rounding, if that is the explanation.

5. Indicate whether the table should be read across or down by placing the total(s) at bottom or extreme right.

6. Be consistent in the format of your tables. In general, put the variable you are exploring (the *dependent variable*) in the left column and make the independent variables the column heads.

7. Provide a title for the table that is complete and makes the table self-explanatory.

8. When appropriate, include the actual text of the survey question for which results are being reported.

Frequency distributions are as simple or as complicated as the questions on which they are based. The table on *Comparative Audience Rating of Event* presents a somewhat more complicated example.

Comparative audience rating of event

Question: Compared with what you expected, how would you rate this event?

Rating

Much better than expected	10%
Better	30%
About the same	25%
Not as good	20%
Much worse than expected	15%
	100% (N = 380)

As you can see, there were five possible fixed responses to the question. One out of ten respondents (10 percent) rated the event as being "much better than expected," about one-third (30 percent) rated it "better," and so on. The total sample size here was 380 respondents, so 20 people completing the questionnaire did not answer this question.

Using this same example, let's consider two additional matters: regrouping data and the question of "no response." First, regrouping: there will be times when you want to rearrange, regroup, or "collapse" your data. Treating results in this fashion is perfectly acceptable and will let you highlight certain aspects of the findings.

☒ Regrouping data

Here are two examples of how frequency data can be regrouped. In Example A, the data have been collapsed to highlight strong opinions. In Example B, the data have been grouped to more clearly show audience satisfaction and dissatisfaction.

Question: Compared with what you expected, how would you rate this event?

Example A

Much better than expected (10%)	Very positive (10%)
Better (30%)	
About the same (25%)	No strong opinion (75%)
Not as good (20%)	
Much worse than expected (15%)	Very negative (15%)

Example B

Much better than expected (10%)	
Better (30%)	Satisfied (65%)
About the same (25%)	
Not as good (20%)	Dissatisfied (35%)
Much worse than expected (15%)	

In Example A, the five-step rating scale has been compressed into three steps. The distribution of responses has been reworked to indicate "very positive" opinion, "very negative" opinion, and the great proportion of "no strong opinion."

In the second illustration, the same five fixed responses have been collapsed into two groups, "satisfied" and "dissatisfied." Depending on the story you are trying to tell, regrouping frequency distributions may be a helpful approach.

How you handle the "no response" or missing data problem is another matter. In all surveys, there will be questions that not everyone has answered. The issue then becomes: How should the frequency distribution be calculated? Should percentages be computed using the entire sample as the denominator? Or should the responses be proportioned against a base of only those who have answered the question? It might make a difference.

Comparative audience rating of event

Question: Compared with what you expected, how would you rate this event?

Rating	Respondents answering question	All respondents
Much better than expected	10.0%	9.5%
Better	30.0%	28.5%
About the same	25.0%	23.8%
Not as good	20.0%	19.0%
Much worse than expected	15.0%	14.2%
(No response)	—	5.0%
	100.0%	100.0%
	(N = 380)	(N = 400)

Note: In general, data should be rounded off to whole numbers since survey data is relatively "soft" and presenting decimal numbers gives an impression of false precision.

The frequency distribution given in one column was calculated against an "N" of 380, while the distribution in the other column is based on an "N" of 400. This tells you that 20 people in the total sample did not answer the question. It also shows that they do not significantly affect the results. Which frequency distribution is the right one depends on your purpose and on the size of the "no response" category. If it is important to know that a large (or small) proportion of your sample did not answer a question, then it is better to include the "no response" category. However, if the percentage of missing data is small, say, under 10 percent, and if there is no substantive reason for including it in the table, leave out the "no response" category. Remember, though, if you have not included information about "no responses," the text of your report should reflect this omission. You will want to say something like, "Of course with an opinion . . . or "Of respondents answering this question" If the proportion is large, however, say, 25 percent or more, some interpretation must be included in your report. It could mean indifference to the question, the question was misunderstood, or the question was too sensitive.

The cross-tabulation

Cross-tabulation is probably the technique most frequently used to analyze survey data. Constructing and reading a cross-tab is not hard, but it does take some practice. Think of cross-tabulation as an extension of frequency distribution. Logically, there are four steps to a cross-tabulation: (1) sort respondents into analytically meaningful groups (e.g., men/women; attenders/nonattenders; young/middle-aged/older); (2) calculate the frequency distribution within each group for the variables (e.g., age, sex) you want to analyze; (3) compare the group frequency distributions to the frequency distributions for the total sample; and (4) repeat the comparisons between groups.

Comparative audience rating of event by sex of respondent

61

	Respondents' sex		
Rating	*Male*	*Female*	*All*
Much better than expected	15%	5%	10%
Better	25%	35%	30%
About the same	25%	25%	25%
Worse	20%	20%	20%
Much worse than expected	15%	15%	15%
	100%	100%	100%
	(n = 180)	(n = 220)	(N = 400)

In this hypothetical example, the arts organization wanted to know whether men and women rated a specific arts event differently. Or, put another way, does respondent's sex influence his or her evaluation of the event. Since respondent's sex may determine the rating, it is called the *independent* or *TAB* variable. The rating is the *dependent* or *RESPONSE* variable.

To create a cross-tabulation, the computer sorted all respondents into men and women as recorded in one of the demographic questions. It next computed a frequency distribution for men and women separately on the answers to the rating question. The data clearly show that more men than women had a much better time at the event than they expected. One out of six (15 percent) said "much better than expected," while women were one-third as likely (5 percent) to give a similar response. Women, however, were somewhat more likely (35 percent to 25 percent) to say their experience had been "better" than expected, and there were no differences between men and women in the proportions of neutral ("about the same") or negative ("worse" or "much worse") responses.

Like all cross-tabulations, this one contains a great deal of information. By reading down the far-right column, for example, you can find out how the entire sample of respondents answered the rating question. This is because adding the responses of men and women together gives you the answers of all respondents. A frequency distribution of this type, based on the entire sample, is called the *marginal frequency* because it appears at the edge or margin of the table. The numbers making up the frequency distributions for men and women are "inside" the table and, in survey parlance, are known as the *internals*.

One other piece of information worth noting is the size of the male subsample (n = 180) and of the female subsample (n = 220). The overall sample size is, of course, N = 400. When reading a cross-tab, it is important to check the size of the subsamples. If the subsample is small, then the frequency percentage in the cells of the column containing the frequency distribution may be based on a count of very few people, and that could lead to percentages that are misleading. You would not, for instance, want to make very much out of differences in percentages if those figures were based on many fewer than 20 respondents.

Note, finally, that the illustrated cross-tabulation is meant to be read from top to bottom; that is, the frequency distributions add up to 100 percent going down the columns. So you read the table "down." But you make comparisons between the responses of men and women by examining percentages "across" rows, comparing, say, the 25 percent of men who said "better" to the 35 percent of women who gave the same answer.

Cross-tabs can also be read across the rows and comparisons down the rows. In the box below the researchers wanted to know how respondent age affected the spontaneity of event attendance. Here, age is the independent or TAB variable and time of decision to attend is the dependent or RESPONSE variable. Although it is generally a good rule to put the independent or TAB variable at the top of a cross-tab chart and to run the dependent or RESPONSE variable down the left side, sometimes you will want to reverse the positions. Table layout is often changed to make a chart fit a page or to emphasize a point. In this example, the time-of-decision variable is broken into two responses (planned and last-minute), while the age variable has eight possible answers ("Under 18" through "Over 65"). Quite simply, the table looks better and can be understood more easily the way we have designed it.

☒ Age and spontaneity of event attenders

Question: Would you say you planned in advance to attend today's event or did you make a last-minute decision to attend?			
Age	Planned in advance	Last-minute decision	Total
Under 18	75%	25%	100% (n = 63)
18 to 24	76%	24%	100% (n = 18)
22 to 29	78%	22%	100% (n = 27)
30 to 39	33%	67%	100% (n = 45)
40 to 49	38%	62%	100% (n = 63)
50 to 59	70%	30%	100% (n = 54)
60 to 65	72%	28%	100% (n = 54)
Over 65	77%	23%	100% (n = 36)
Respondents answering	63%	37%	100% (N = 360)

And what does this table say about age and the spontaneity of event attendance? Quite a lot. It appears from the data that the youngest and oldest attenders are the least spontaneous deciders, and that the middle-aged are the most. Three-quarters or more of respondents twenty-nine years old or younger (75 percent, 76 percent, 78 percent) said they planned their attendance in advance as did almost as many people fifty or older (70 percent, 72 percent, 77 percent). By contrast, fewer than two out of five respondents thirty to fifty years old (33 percent, 38 percent) had planned to attend, while three-fifths or more (62 percent, 67 percent) said their attendance was a "last-minute decision."

Notice that within age categories, responses about advance planning or last-minute decisions add up to 100 percent across the row. Notice also that the sample sizes within age groups are considerably smaller than the total "N." For example, only eighteen respondents in this study were eighteen to twenty-four years old. That is a small "n," so some care should be exercised in interpreting this particular result. You can use the table on page 26 to gauge the variances (plus/minus) that go with subsamples of different size. Collapsing the age groups in the last example is one way to increase the subsamples. Don't subdivide your subsample more than necessary. If it is important to subdivide finely (disaggregate), you may need to have a larger sample (N) so that the subsamples (n) are large enough to have the precision you want.

Cross-tabulation and causation. In the two examples we have just examined, certain variables (sex, age) were labeled as the independent or *TAB* variables and others (event satisfaction, spontaneity) were considered as the dependent or *RESPONSE* variables. Implied in this labeling is the idea that independent variables in some way cause changes or differences in dependent variables; that, for example, there is something about being male or female which increases or decreases the enjoyment of arts attendance.

Without engaging in a long discussion of the difficulties in demonstrating a definite cause-and-effect relationship when you are dealing with critters as ornery and unique as human beings, we do want to alert you to the issue of causation. At times, it will be easy to say that Variable A causes Variable B. In that case, the causal direction is from A to B. But in most instances the direction of causality will be less clear. Variable A might cause Variable B, but it also might be plausible that Variable B is causing changes in Variable A. Worse yet, there will be times when Variable A and Variable B interact with each other, so that A causes B and at the same time B causes A. And it is also possible that A and B are both caused by something else (not each other) and that something else may or may not be measurable. If you are aware of this potential danger, then you can exercise caution when reporting your results. That is a particularly good idea when dealing with two closely related measures of attitudes. Specifying which chicken is causing which egg may be very difficult if not impossible, and turning your survey into usable policy often can be done without it.

Tests of statistical significance. When reading a cross-tab table, the question often arises: Are these differences real or are they only a consequence of sampling? After all, there is always some error in sample estimates. How do you know whether a difference between young people and older attenders represents a true difference? The use of the table on page 26 tells you about variance (plus/minus) of your results. Beyond this, there are statistical tests that can tell you whether the differences you see are real; whether, in the language of the statisticians, they are

statistically significant. Among the most common of these tests are measures with such names as Chi-square, T-test, and F-ratio. Using these statistical tests takes some training, but no good survey researcher reports his or her findings without first knowing their statistical significance. Ask your data-processing professional to include the appropriate tests of significance when running your data. The ability to do this is built into most computer software for preparing tables such as SPSS. And if you cannot interpret the tests' results yourself, ask someone who can.

Finally, remember that just because something is statistically significant does not automatically mean that it has *substantive* significance. Statistical significance is only the first step in evaluating survey data. Knowing if it has any practical, policy significance is something only you can decide.

One final point applies to frequency distribution and cross-tabulation. When writing a report based on survey data, characterizing proportions makes for a livelier, more comprehensible text. For example, saying "a few" or "a large majority" favor or oppose a hike in season ticket prices will give your reader a better grasp of the numbers and their implications. If a good purpose is served, the actual numbers or percentages can be given in parentheses. Here are some rules of thumb that will help you decide "how large is large?"

☒ How large is large?

> In reporting survey results, you may want to characterize the size or magnitude of a given finding. What adjective, for example, would you apply to a finding that 22 percent of your sample disagreed with a given statement. Some? A small proportion? A handful? While there is no universal set of rules for applying qualitative terms to survey results, here is one pretty good set of guidelines:
>
If the result is:	Characterize the percentage as:
> | From 1% to 20% | "Very few" to "few" |
> | From 21% to 40% | "A minority" to "a large minority" |
> | From 41% to 50% | "Nearly half" to "half" |
> | From 51% to 70% | "A majority" to "a large majority" |
> | From 71% to 90% | "A great number" to "a very great number" |
> | From 91% to 99% | "Almost all" |

Writing a survey report

No survey is complete until a detailed and extensive report is prepared. Obviously, such a report should address the problems or issues you started out to study and should marshal all the evidence that is relevant to the policy matters at hand. There are, however, some less obvious things, both large and small, that make for a better, more readable, more action-oriented report. Here are some things to keep in mind:

1. Provide an executive summary. Every report of a survey should include a brief, brisk, policy-relevant statement highlighting what was found and what it means. Save the complicated analyses, tables, and methodology for other sections of the report.

2. Relegate most details about the survey's methodology to a technical appendix and include there the dates the survey was done, the population sampled, sample size, type of sampling, response rates, and any other information that has a bearing on the quality of the survey.

3. Include a complete copy of the questionnaire. You may want simply to photocopy an actual survey instrument. Or you may want to provide a typescript version of the questionnaire.

4. Highlight and discuss important findings from the tables. Some people cannot or will not read the tables, so put the meaning of those tables into words and position that text near the tables.

5. When reporting data, use fractions and put the actual percentages in parentheses. For example: "About two-thirds (65 percent) of attenders came from the Jackson area." And keep the fractions sensible (e.g., one-quarter, one-third, one-half). Most people are not used to thinking about a sixteenth or twenty-fourth.

6. Report whole percentages both in tables and in your text. Do not write "44.2 percent"; make it "about 45 percent." Unless your sample is very large, sampling error alone will make it impossible to calculate percentages with any greater precision.

7. Leave out some details (but not the important ones). It is, for example, unnecessary to report all the frequencies for all values of a given variable. Collapsing results reduces the level of detail but also leads to a more understandable report.

8. Point out small samples or subsamples. Warn readers when the number of respondents is small, say, under twenty-five people. And use data based on small samples with extreme caution.

9. Convey a proper sense of tentativeness. No survey is absolutely definitive; no figure in a survey is exactly correct. Don't pretend to have precision that is not there. Better to report results as being "about," "approximately," or "close to."

10. Write simply and communicate. Eschew obfuscation. Keep technical jargon to a minimum. Simple, declarative sentences work best.

Appendix
Model Survey Questions

67

This appendix contains more than fifty different questions especially designed for surveys of the arts audience. The questions are set up in a generic form to allow you to insert specific names, places, events, etc. Five basic categories of questions are presented:

Audience demographics
Audience satisfaction
Motivations for attending
Marketing and pricing
Assessment of facilities

The model questions are numbered sequentially only to help distinguish between them. The actual order of the items in a questionnaire depends on the questions you choose and on the special purposes of the survey.

The wording of all of these model questions is most suitable for a self-administered questionnaire. In the case of a survey by telephone or personal interview, many question wordings and instructions will require some modification.

Audience demographics

The fourteen model questions that follow cover the usual types of demographic items in most surveys: gender, marital status, age, education, work status, occupation, income, ethnicity, and number of children. You may not need to use all of the fourteen model questions, and you may want to modify the answer categories if your audience has somewhat different or unique characteristics. Please be alert to the sensitivity that many audiences will have to questions about work status, occupation, and income. Many people refuse to answer questions on these matters or, worse, give incorrect answers. Also, the technical issues in classifying "occupation" are complex and experts disagree on the suitability of the several approaches that are often used (Chapter II). The occupation categories in the following model question 06 are similar to the ones used by Bureau of the Census and Bureau of Labor Statistics. The twelve occupation groupings in the model question may be too detailed for your needs. You may "collapse" some of these categories by combining several into fewer groups, but try to do it in a way that does not cross over or split up the starting categories or you will not be able to compare the results with Census data for your location.

Students at the Museum of
Modern Art, 1985.

01. Are you: (Circle one.)

1—Female 2—Male

02. And are you: (Circle one.)

1—Married 2—Unmarried

03. Your age is about: (Circle one.)

1—Under 18 3—22 to 29 5—40 to 49 7—60 to 65

2—18 to 21 4—30 to 39 6—50 to 59 8—Over 65

04. And your education: (Circle highest level achieved.)

1—Elementary school 5—Technical school graduate

2—Some high school 6—Community college graduate

3—High school graduate 7—College graduate

4—Some college 8—Postgraduate degree

05. Are you now: (Circle one.)

1—Working 4—Keeping house

2—Looking for work 5—Retired

3—Going to school 6—Other (Specify) _____

06. Which of the following occupations best represents your present job? (Circle one.)

1—Clerical worker (bank teller, bookkeeper, secretary, mail carrier)

2—Skilled worker (baker, automobile mechanic, machinist, painter, plumber, carpenter)

3—Farmer, farm manager, farm laborer

4—Laborer (construction worker, car washer, sanitary worker)

5—Manager, administrator (sales manager, office manager, school administrator, restaurant manager, government official)

6—Military

7—Operative (meat cutter; assembler; machine operator; taxicab, bus, or truck driver)

8—Professional (accountant, artist, clergyman, physician, registered nurse, engineer, lawyer, librarian, teacher)

9—Sales worker (salesman, advertising or insurance agency representative, real estate broker)

10—Service worker (barber, practical nurse, private household worker, janitor, waiter, policeman, guard)

11—Technician (draftsperson, medical or dental technician, computer programmer)

12—Other (Specify) _____

07. About what was your total family income before taxes last year? (Circle one.)

1—Under $10,000 4—20,000 to 29,999

2—10,000 to 14,999 5—30,000 to 50,000

3—15,000 to 19,999 6—Over 50,000

08. Are you: (Circle one.)
- 1—American Indian/Alaskan Native
- 2—Asian/Pacific Islander
- 3—Black, not Hispanic
- 4—Hispanic
- 5—White, not Hispanic

09. If married, are both husband and wife employed? (Circle one.)
- 1—Yes, both are employed
- 2—No

10. Do you own or rent your main residence? (Circle one.)
- 1—Own
- 2—Rent
- 3—Neither own nor rent

11. Are there children under 18 in your household? (Circle one.)
- 1—None
- 2—One
- 3—Two
- 4—Three or more

12. Do any of the following apply to you? (Circle as many as apply.)
- 1—Hearing impaired
- 2—Vision impaired
- 3—Physical handicap

Audience satisfaction

If you use any of the questions in this section, you most likely will want to alter them to fit the specifics of your arts activity. For example, the first question might be adapted to read: "All in all, how did you enjoy the Winslow Homer exhibit?" Remember that a good survey question is, among other things, a specific question. So make the references as explicit as possible.

Note, too, that not all the questions in this section are equally applicable to all arts settings. Question 02 and its detailed subdivisions are appropriate for performing arts events, while question 03 and its detailed subdivisions are appropriate for gallery or exhibit settings. So choose those items that fit your circumstances best.

01. All in all, how did you enjoy [today's, tonight's] [performance, event, show]? (Circle one.)
- 1—A great deal
- 2—Somewhat
- 3—Hardly at all

02. How would you rate the following features of [today's, tonight's] [performance, event, show]? (Circle one number for each feature.)

	Excellent	Good	Fair	Poor
[Principal actor, singer, dancer, player]	1	2	3	4
[Principals] if more than one applies—e.g., singers and players	1	2	3	4
[Supporting actors, singers, dancers, players]	1	2	3	4
[Directing, conducting]	1	2	3	4
[Script, score, lyrics, choreography]	1	2	3	4
[Scenery, settings, stage props, special effects]	1	2	3	4
Costuming	1	2	3	4

03. How would you rate the following features of this [event, exhibit]? (Circle one number for each feature.)

	Excellent	Good	Fair	Poor
Overall quality	1	2	3	4
Feature exhibitions	1	2	3	4
Permanent collection	1	2	3	4
Subject matter	1	2	3	4
Lighting	1	2	3	4
Title cards, labels, explanations	1	2	3	4
Catalogs, brochures	1	2	3	4

04. Compared to what you expected, how would you rate [today's, tonight's] [event, performance]? (Circle one.)
1—Much better than expected 4—Not as good
2—Better 5—Much worse than expected
3—About the same

05. About how many [events, performances, shows] did you attend [of this group] at [place] during the past year? (Circle one.)
1—Just this one 3—Three to five
2—Two 4—More than five

06. Do you feel that this year's [events, performances, shows] are better or not as good as last year's? (Circle one.)
0—Didn't attend last year 3—Not as good
1—Better 4—Really can't say
2—About the same

07. In general, have the [events, performances, shows] you have been to this [season, year] made any difference in your decision to attend future [events, performances, shows]? (Circle one.)
1—Made me *more* likely to attend
2—Made no difference
3—Made me *less* likely to attend

08. On the basis of the [events, performances, shows] you have been to this [season, year] would you recommend future events to a friend? (Circle one.)
1—Yes, definitely 3—No, probably not
2—Yes, probably 4—No, definitely not

09. Did you attend a [workshop, lecture, class] here as well as attending this [performance, event]? (Circle one.)
1—Yes 2—No

10. Did you purchase a [catalog, program, printed matter] while attending this [performance, event]? (Circle one.)
1—Yes 2—No

11. All in all, what did you like best about [today's, tonight's] [event, performance]? (Please write in.)

And what did you like least? (Please write in.)

12. Did you attend a [workshop, lecture, class] while at [this place]? (Circle one.)
 1—Yes 2—No

13. How well do the following comments describe this [workshop, lecture, class]? (Circle one number for each comment.)

	Very well	Quite well	So-so	Not too well	Not at all well
Presented new ideas and concepts clearly	1	2	3	4	5
Was entertaining	1	2	3	4	5
Was educational	1	2	3	4	5
Helped me to understand the past	1	2	3	4	5
Stimulated creativity	1	2	3	4	5
Was shocking	1	2	3	4	5
Stimulated thought	1	2	3	4	5

14. How well does [this place] do the following? (Circle one number for each amenity.)

	Very well	Quite well	So-so	Not too well	Not at all well
Use information labels	1	2	3	4	5
Use audio-aides	1	2	3	4	5
Provide related literature	1	2	3	4	5
Organize guided tours	1	2	3	4	5
Provide assistance from staff	1	2	3	4	5

15. How interested are you in attending the following kinds of exhibits or activities? (Circle one number for each kind of exhibit or activity.)

	Very	Quite	Somewhat	Slightly	Not at all
Folk and craft fairs	1	2	3	4	5
Workshops in household decoration and design	1	2	3	4	5
Contemporary music concerts	1	2	3	4	5
Classical music concerts	1	2	3	4	5
Theatre productions	1	2	3	4	5
Film series	1	2	3	4	5
Studio art classes	1	2	3	4	5
Art or music appreciation classes	1	2	3	4	5
Lectures about exhibits	1	2	3	4	5
Dance performances	1	2	3	4	5

Motivations for attending

The model questions in this section are about why people attend arts events as well as questions that gauge how difficult or easy it was to attend. You will probably want to tailor the questions and possible answers to fit actual local names of places and methods of transportation.

01. Which of the following best describes the chief reason you are at this [event, place] [today, tonight]? (Circle the one that best applies.)
 1—For my own entertainment 5—For job-related reasons
 2—To be with friends 6—For educational reasons
 3—To be with husband, wife, friend 7—Other (Please write in.) _____
 4—To take children _____

02. Where were you today just before you came to this [event, place]? (Circle one.)
 1—At home 5—At restaurant
 2—Shopping 6—Vacationing/sightseeing
 3—At work 7—Other (Please write in.) _____
 4—At meeting or conference _____
 other than regular work

03. How much time did you spend [today, tonight] at this [event, place]? (Circle one.)
 1—Less than one hour 3—Two to four hours
 2—One to two hours 4—More than four hours

04. What is the zip code of your home address? (Please write in.) _____

05. About how far did you travel today to come to this [event, place]? (Circle one.)
 1—Less than 1 mile 3—5 to 9 miles 5—20 to 50 miles
 2—1 to 4 miles 4—10 to 19 miles 6—Over 50 miles

06. And about how long did this trip take? (Circle one.)
 1—Less than 15 minutes 3—Over 30 minutes but less than 1 hour
 2—15 to 30 minutes 4—One hour or more

07. All in all, how easy was it for you to attend this event? (Circle one.)
 1—Very easy 3—Not very easy
 2—Fairly easy 4—Not at all easy

08. How did you get to this [event, place]? (Circle one.)
 1—Walked 5—Took train
 2—Drove own auto 6—Some other (Please write in.) _____
 3—Rode in other's auto _____
 4—Took [bus, subway, trolley, taxi]

09. If you used auto:
 Was it hard to find a parking place? (Circle one.)
 1—Yes 2—No
 About how many blocks from this [event, place] was auto parked?
 (Please write in.)
 _____ blocks
 Did you or your party pay a parking fee? (Circle one.)
 1—Yes 2—No

10. Did you have definite plans to come to this [event, place] [today, tonight] or was it a
 last-minute decision? (Circle one.)
 1—Had definite plans 2—Last-minute decision

11. Are you at this [event, place] as part of an organized group (for example, theater
 party, guided tour, church group, etc.)? (Circle one.)
 1—Yes 2—No

12. Are you at this [event, place] [today, tonight] by yourself or with someone? (Circle
 as many as apply.)
 1—By myself 5—With organized group
 2—With friend or friends 6—Other (Please write in.) _____
 3—With husband or wife _____
 4—With children

The model questions in the following section are to help make decisions on how to promote arts events and what prices to charge. Clearly, these questions will require much adjusting and tailoring to fit individual circumstances. The need for the specific marketing and pricing questions should be well established before starting the work of preparing a questionnaire. You should know what alternatives you want to include in your questionnaire and you should have agreement from the other decision makers in your organization on the answers that may make a difference. Select only the model questions that are relevant. Use as few as you can. Modify the wording and the answer choices so that the results will really matter.

01. Did you purchase your own ticket? (Circle one.)

1—Yes, at box office 4—Yes, by telephone

2—Yes, from someone else 5—Yes, by mail

3—Yes, at Ticketron 6—No, it was given to me

02. What was the price of your [ticket, admission] to [today's, tonight's] [event, place, show]? (Circle one.)

0—Don't know 1—(As applies) 2—(As applies)

03. What type of [ticket, admission] do you have? (Circle one.)

0—Don't know 5—Senior citizen discount

1—Single performance 6—Student

2—Season or subscription 7—Other (Please write in.) _____

3—Pass _____

4—Group or party

04. When was your [ticket, admission] purchased? (Circle one.)

0—Don't know 3—By mail reservation

1—At [box office, desk] on day of event 4—By phone reservation

2—At [box office, desk] before day of event 5—Earlier through organized group

05. Which of the following are the first and second most important to you in deciding to [attend, visit] [events, shows] at [this place]? (Circle only one first reason and one second reason.)

	First reason	Second reason
Convenience of location	1	2
Parking facilities	1	2
Nearby dining	1	2
Phone reservations	1	2
Credit card ticket charge	1	2
Shopping in Sales gallery	1	2
Attractiveness of displays or buildings	1	2
Other (If other, please specify.)	1	2

06. In general how do you feel about the price of [a ticket, admission] to this [event, place, show]? (Circle one.)

0—Don't know 3—About right

1—Too little 4—Somewhat too much

2—Somewhat too little 5—Too much

07. If the price of a [ticket, admission] to future [events, places, shows] were [$x\%$, x dollars] less, how likely is it you would attend more often? (Circle one.)

1—Likely more often 3—Likely less often

2—About the same 4—Don't know

08. If the price of a [ticket, admission] to future [events, places, shows] were [$x\%$, x dollars] higher would you attend less often? (Circle one.)

1—Likely less often 3—Likely more often

2—About the same 4—Don't know

09. Are you a [member, sponsor, subscriber] of this [event, place, organization]? (Circle one.)

1—Yes 2—No (Continue with question 10.)

If yes:

How do you feel about the cost of [membership, sponsorship, subscription]? (Circle one.)

1—Too little 4—Somewhat too much

2—Somewhat too little 5—Too much

3—About right

If the cost of [membership, sponsorship, subscription] were (x dollars) higher, would you continue as a [member, sponsor, subscriber]? (Circle one.)

1—Definitely yes 4—Probably no

2—Probably yes 5—Definitely no

3—Can't say

10. If you are not now a [member, subscriber, sponsor], do you know how much it would cost to become a [member, subscriber, sponsor]? (Circle one.)

1—Yes 2—No (Continue with question 11.)

If yes:

If the cost of [membership, subscription, sponsorship] were (x dollars) lower, would you then become a [member, subscriber, sponsor]? (Circle one.)

1—Definitely yes 4—Probably no

2—Probably yes 5—Definitely no

3—Can't say

11. If there were an admission fee for future [shows, events, exhibits] would you be likely to attend? (Circle one.)

1—Definitely would	4—Probably would not
2—Probably would	5—Definitely would not
3—Can't say	

12. How did you learn about this event? (Circle one number for each.)

	Yes	No
Friends	1	2
Newspaper or magazine	1	2
Television	1	2
Radio	1	2
Poster or flyer	1	2
Mail	1	2
Other (Write in.)		

13. Which of the following are the two most important reasons for your decision to attend this [event, show, exhibit]? (Circle only one first reason and one second reason.)

	First reason	Second reason
[Who, what] is in the [cast, exhibit]	1	2
Low cost of admission	1	2
What others have told you	1	2
Husband, wife, or friend attending with you	1	2
Advertisements	1	2
What critics have said	1	2
Past experience with [event, performance]	1	2
Reputation of [composer, playwright, artists]	1	2
Reputation of the [company, gallery, museum]	1	2
Other (If other, please specify.)	1	2

The applicability of these model questions to your particular arts event is dependent upon the type of setting. There should be no great problem in adapting particular items for your own questionnaire if these models are more or less relevant. The model questions are very general, however, and in the nature of evaluations of existing conditions. You may need special questions to get answers to issues concerning changes to facilities or the need for new and different facilities.

01. How would you rate the following features in [today's, tonight's] [performance, event, exhibit]? (Circle one number for each feature.)

	Very good	Good	Fair	Poor	Don't know
Size of (auditorium gallery, display area)	1	2	3	4	5
Lighting	1	2	3	4	5
Sound	1	2	3	4	5
Freedom from (distracting noise, movement)	1	2	3	4	5
Ventilation	1	2	3	4	5
Temperature	1	2	3	4	5
Visibility	1	2	3	4	5
Your seat for tonight's performance	1	2	3	4	5
General (seating arrangements, viewing arrangements)	1	2	3	4	5
Ease of entering	1	2	3	4	5
General attractiveness	1	2	3	4	5
Adequacy of public lobby	1	2	3	4	5
Adequacy of restrooms	1	2	3	4	5
Location of performing area	1	2	3	4	5
Helpfulness of (ticket office, ushers, docents, guides)	1	2	3	4	5
Parking facilities	1	2	3	4	5

02. Were you able to sit where you wanted to (today, tonight)? (Circle one.)
1—Yes 2—No

If no, why was this? (Please write in.) _____

Motion picture audience
watching 3-D movie, 1952.

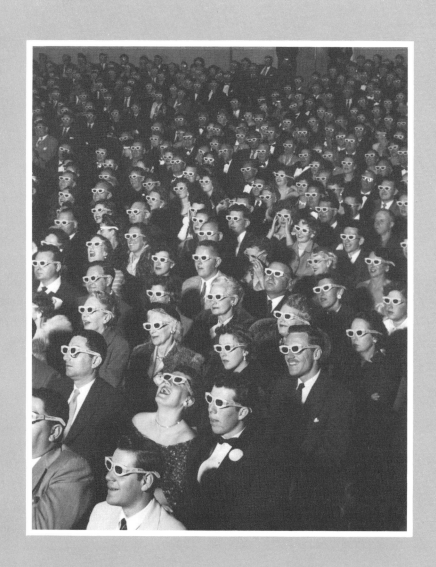

Research division reports

Since 1976 the Research Division of the National Endowment for the Arts has been studying matters of interest to the arts community and issuing reports based on its findings. Eighteen of these have been published to date.

#1. Employment and Unemployment of Artists: 1970-1975. Census data and Bureau of Labor statistics findings charted to compare unemployment among various kinds of artists and the general labor force. April 1976. 32 pp. Paper

#2. To Survey American Crafts: A Planning Study. An assessment of information about craft artists and their work, prepared as an aid to planning of new research. July 1977. 32 pp. Paper

#3. Understanding the Employment of Actors. Data from the personnel files of Actors' Equity Association interpreted by Arts Endowment researchers help explain theatre employment data systems and the complex conditions governing economic survival of actors. Sept 1977. 36 pp. Paper

#4. Arts and Cultural Programs on Radio and Television. Considers how broadcasting executives understand the phrase ''arts and cultural programming,'' shows how audiences, scheduling and funding for such programs compare with those for other types of programs and indicates what kinds of arts programs would be welcomed by broadcasters if available. Sept 1977. 92 pp. Paper

#5. Where Artists Live: 1970. Tables, maps, and text summarize census data that show national distribution of the American artist population. Oct 1977. 80 pp. Paper

#6. Economic Impacts of Arts and Cultural Institutions: A Model for Assessment and Case Study in Baltimore. A general method for estimating the effects of arts and cultural institutions on the economic environment of their communities. Nov 1977. 96 pp. Paper

#7. Minorities and Women in the Arts: 1970. Census data analyzed to reveal the sex and minority makeup of our artist population. Jan 1978. 32 pp. Paper

#8. The State Arts Agencies in 1974: All Present and Accounted For. Summarizes the status and activities of state arts agencies in the first year in which all fifty states, the District of Columbia, and four U.S. territories had fully operational arts councils. April 1978. 160 pp. Paper

#9. Audience Studies of the Performing Arts and Museums: A Critical Review. Evaluates the methods and relative effectiveness of 270 completed audience studies and considers the implications of their collective findings. Nov 1978. 106 pp. Paper

#10. Selected Characteristics of Artists: 1970. Self-employment patterns, migration patterns, and household and family characteristics of artists as revealed in census data. Nov 1978. 32 pp. Paper

#11. Conditions and Needs of the Professional American Theatre. Data and analysis aimed at understanding the conditions of professional theatre in America and the evolving relationship between commercial and nonprofit theatre. Contains advisory panel's recommendations for changes in public policy. May 1981. 132 pp. ISBN 0-89062-076-8 Paper

#12. Artists Compared by Age, Sex, and Earnings in 1970 and 1976. Census data compared with the 1976 Survey of Income and Education to reveal changes in the size and composition of America's artist population during the 1970s; establishes trends that will be subjected to further study as 1980 census data become available. Jan 1980. 56 pp. ISBN 0-89062-077-6 Paper

#13. Craft Artist Membership Organizations 1978. Detailed survey of 1,218 craft artist organizations in all parts of the United States with data on size, location, media preferences, membership screening, facilities, staffing, expenses, and funding. Jan 1981. 52 pp. ISBN 0-89062-089-X Paper

#14. Audience Development: An Examination of Selected Analysis and Prediction Techniques Applied to Symphony and Theatre Attendance in Four Southern Cities. Marketing strategies applied to the problems of turning marginal arts attenders into regular patrons show pitfalls in some traditional promotional techniques and underscore the importance of life-style analysis in relation to arts attendance. Atlanta, Baton Rouge, Memphis, and Columbia (South Carolina) are studied. Jan 1981. 48 pp. ISBN 0-89062-097-0 Paper

#15. Economic Impact of Arts and Cultural Institutions. Analysis and comparison of how money flows between arts and cultural institutions and local economy through institutional, staff, and audience expenditures and municipal and state revenues and support. Columbus, Minneapolis/St. Paul, St. Louis, Salt Lake City, San Antonio, and Springfield (Illinois) are studied. Jan 1981. 104 pp. ISBN 0-89062-106-3 Paper

#16. Artist Employment and Unemployment 1971-1980. Year-by-year data from the Current Population Survey used to compare employment in different arts occupations during the 1970s decade. The data show growth in the artist population greater than that of the American labor force as a whole. Jan 1982. 44 pp. ISBN 0-89062-138-7 Paper

#17. The Arts Public in the South. Data on leisure activities in thirteen states revealing extraordinarily high involvement in choral and choir music and indicating increased future participation in arts-related activities. March 1984. 60 pp. ISBN 0-89062-147-0 Paper

#18. Visual Artists in Houston, Minneapolis, Washington, and San Francisco: Earnings and Exhibition Opportunities. Examines conditions under which artists outside primary urban centers are currently pursuing careers. Spring 1984. 48 pp. ISBN 0-89062-191-8

#19. Where Artists Live 1980. Analyzes the data gathered in the 1980 U. S. Census and compares them with the figures of 1970 to reveal growth and movement in the artist population. Fall 1985. 48 pp. ISBN 0-89062-209-4 Paper $8.00n

The research reports are produced and distributed by the Publishing Center for Cultural Resources, 625 Broadway, NYC 10012. Send for price list.